Drawing and Painting
Flowers with
Coloured Pencils

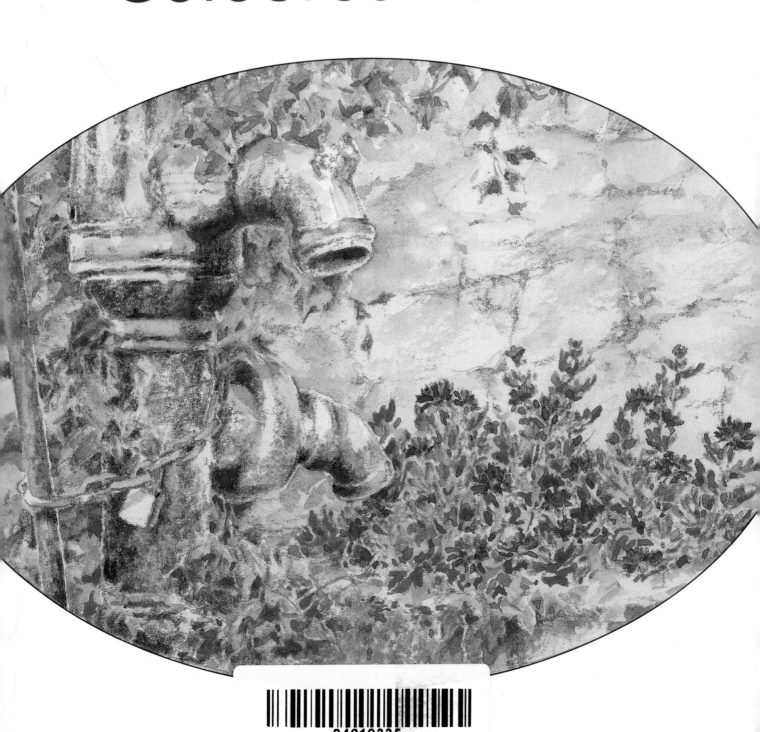

Dedication

To my husband Michael, for his
patience and kindness during the
making of this book.

Drawing and Painting
Flowers with
Coloured Pencils

Trudy Friend

Search Press

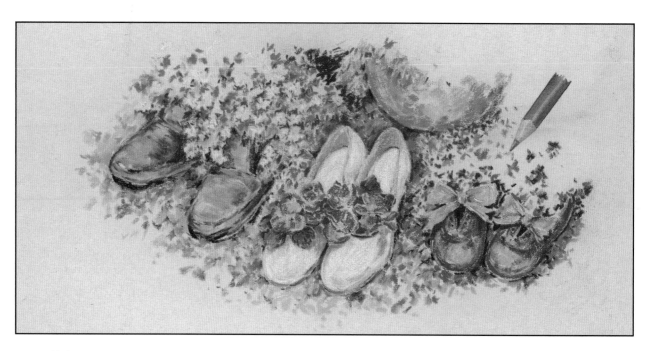

First published in 2014

Search Press Limited
Wellwood, North Farm Road,
Tunbridge Wells, Kent TN2 3DR

Text copyright © Trudy Friend 2014

Photographs and design copyright © Search Press Ltd 2014

ISBN: 978-1-84448-942-8

Suppliers

For details of suppliers, please visit the Search Press website: www.searchpress.com.

Printed in China

Acknowledgements

I am most grateful to all the kind people who let me use their photographs as reference, and my special thanks to Leslie Pace. Chris Moore kindly supplied the charming image on page 54. My thanks also to St Cuthberts Mill for their help and for the photograph on page 29.

Page 1:
Detail from Pump with Chrysanthemums
The full painting is shown on page 71.

Page 3:
Study in contrasts
This study is an excellent example of using multiple media – pencils from the studio, inktense and aquatone ranges – to show the variety of shapes, textures and tones.

Above:
Family Arrangement
This small picture was worked in pastel pencils.

Opposite:
Detail from Flowerpot
A detail taken from the composite painting on pages 34–35.

Contents

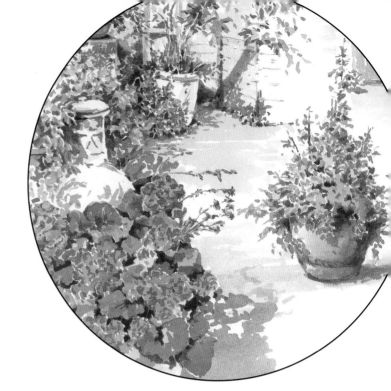

Introduction

Whether arranged in containers or gardens, in the commercial landscape or growing wild in our fields and woodlands, flowers are not usually seen in isolation – they usually relate to something else. There is an immense choice of subject matter, and the potential of flowers for creating arresting, beautiful pictures is almost endless.

All of the pictures in this book are worked in different ranges of coloured pencils. Some are vibrant, some are more subtle. As I will demonstrate in this book, at least one range will produce the effects desired in order to draw and paint flowers exactly how you wish. Artists' pencils, for example, are fantastic for producing slightly textural, dry work that allows you to place masses of flowers against stonework; while inktense pencils and aquatone allow you to explore more painterly watercolour effects for smooth close-up petals and stems.

I believe that an understanding of how plants develop can be a great help in our depiction of flowers. Drawing and painting elements other than the flower heads in full bloom – such as surrounding foliage and roots – and carefully observing the ongoing development that occurs before, during and after a flower's petals have fallen provide an artist with continuing involvement in a flower's lifespan. In turn, this knowledge will inform your drawing and painting of appealing, beautiful flowers.

Let us begin by examining the different ranges of pencils available and the techniques with which they are employed. We will then be ready to move on to explore the depiction of flowers in containers, in gardens, and in open countryside. I wish you luck and enjoyment in your floral artwork.

Opposite:
Through the Greenhouse

Watercolour pencils were used for this study of greenhouse plants, as their soft texture allows strong washes to be laid down quickly. The tall dark plants on the right are Aeonium 'Zwartkop' and the arrangement also includes amaryllis leaves (below the bench) as well as the more familiar geraniums. Through the far door are examples of jasmine and fuchsia.

6

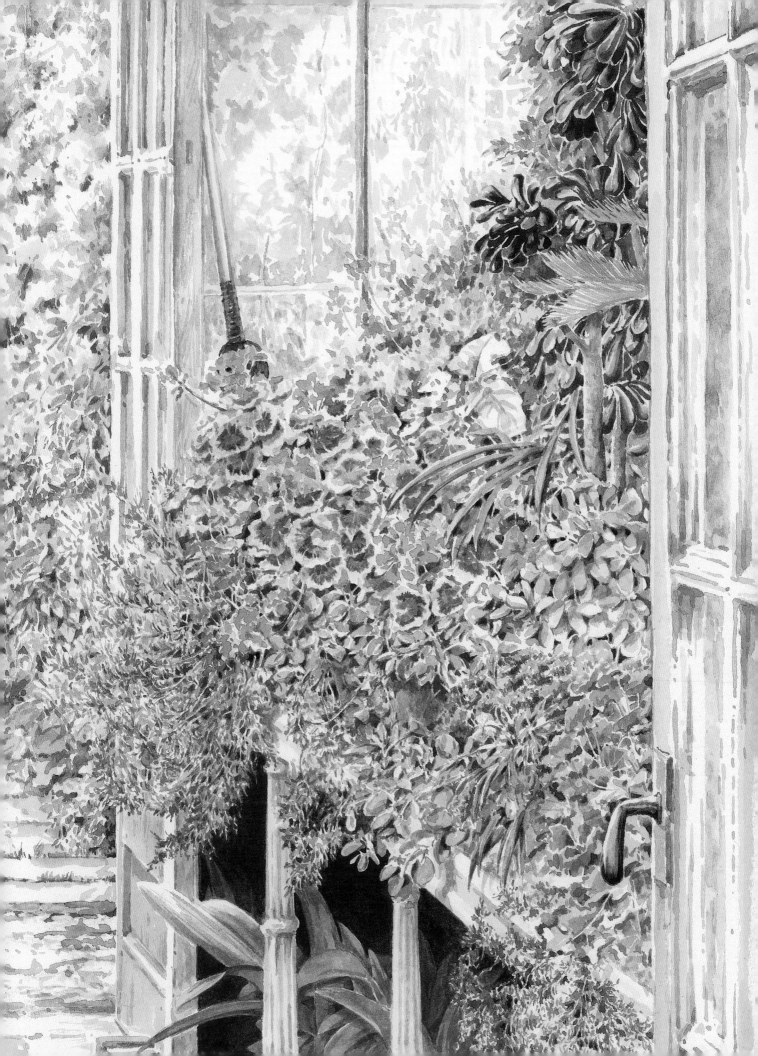

Materials

Whether you want to draw and paint flowers in detail or more loosely, there is a range of coloured pencils you will find suitable. Before you begin, it is important to know the qualities of the pencils you will use. The following pages explain the qualities of each of the ten ranges of pencils I have used in this book, together with suggestions for their use and finished flower drawings. Some of the ranges are smaller than others, or lack particular hues. You should feel free to combine pencils from different ranges, such as the large watercolour pencil range, in your artworks if you need a particular colour. I also explain the different surfaces and supporting materials necessary for successfully drawing and painting your flowers.

Artists' pencils

This is the first range of colour pencils that Derwent developed in the 1930s. They have traditional round barrels and relatively hard, wide cores (the central 'lead' of the pencil), making them perfect for fine botanical detail if used more upright, or for broad strokes if used flatter against the paper. The non-watersoluble core is made of pigment in a waxy filler. This is abraded and left behind as it is drawn over the paper surface, exactly like a graphite pencil.

These pencils allow you to create both free, expressive flower drawings and finer, more detailed work. Their slightly waxy texture is ideal for layering and blending.

Using artists' pencils

Perhaps the most traditional of all the media in this book, artists' pencils are very simple to use. The tip is drawn over the paper exactly like a graphite pencil, and every technique available to those is usable with artists' pencils.

Keep a fine point on the pencils for precision.

Using less pressure results in a soft, light effect, which allows you to place your work before strengthening it with further layers.

Different hues and tints may be produced by layering. Because the core is non-watersoluble, the pencils can only be used dry on dry, and will not react to water. You can use them with solvents like turpenoid natural.

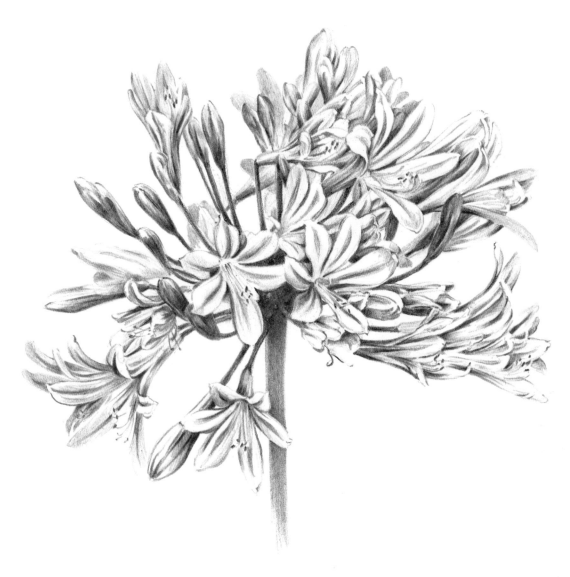

Agapanthus

Also called the African lily, the agapanthus is such an attractive container plant that I wanted to include it in this section where I have the opportunity to depict the detail. Long, sweeping strokes follow the form of the funnel-shaped flowers. Artists' pencils, sharpened to a fine point, are ideal for cutting in crisply to bring the lighter petals forward and emphasise contrasts within the massed blooms.

Working on Derwent's sketch book paper, the two main colours I used were ultramarine and a hint of dark violet. The initial drawing has been blended with a fine brush dipped in turpenoid natural (see page 45 for information on blending using a solvent).

Studio pencils

Studio pencils share the same non-watersoluble colour core as the artists' range, with the same waxy texture, and so are completely compatible. However, they are slimmer, making crisp, precise drawing more easily achievable, and the wood barrel is hexagonal rather than round. This makes them ideal for detailed illustrations as they are easier to grip and therefore more steady.

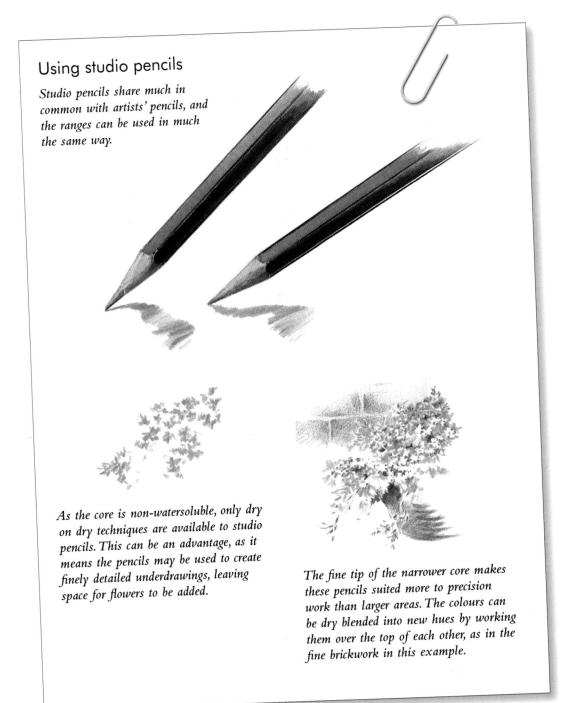

Using studio pencils

Studio pencils share much in common with artists' pencils, and the ranges can be used in much the same way.

As the core is non-watersoluble, only dry on dry techniques are available to studio pencils. This can be an advantage, as it means the pencils may be used to create finely detailed underdrawings, leaving space for flowers to be added.

The fine tip of the narrower core makes these pencils suited more to precision work than larger areas. The colours can be dry blended into new hues by working them over the top of each other, as in the fine brickwork in this example.

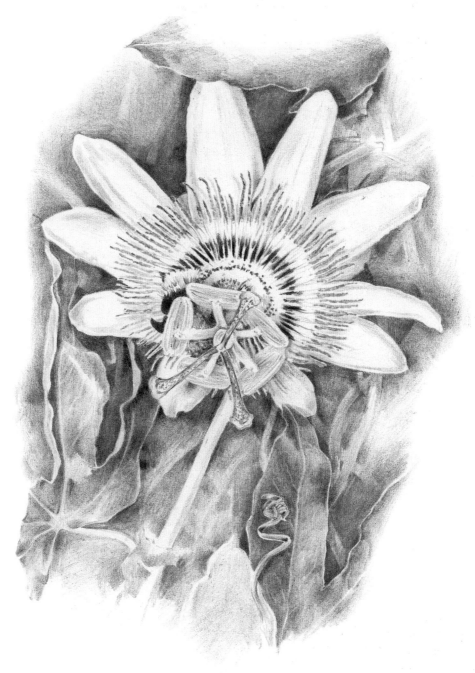

Passion Flower

Studio pencils are ideal for representing intricate blooms like a passion flower, where precise drawing is essential.

The passion flower plant is a strong climber, using walls and other plants, shrubs and trees for support. I have drawn one of the clinging tendrils in front of a lower leaf and, for detail of this nature, found studio pencils to be the natural choice.

Coloursoft pencils

This range has an extremely soft core in comparison with the artists' and studio ranges, and coloursoft pencils create rich, dense areas of colour. These pencils are non-watersoluble, but because they are so soft, the colour they apply can be mixed and blended to create exciting effects upon textured paper.

When sharpened to a fine point, they work equally well for detailed illustrations on a smooth surface. Owing to their softness, however, they do not hold a point as well as other non-watersoluble pencils.

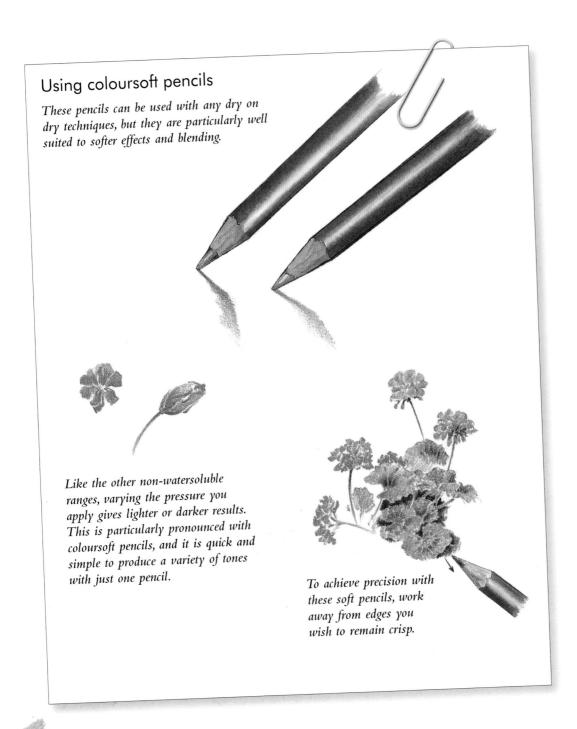

Using coloursoft pencils

These pencils can be used with any dry on dry techniques, but they are particularly well suited to softer effects and blending.

Like the other non-watersoluble ranges, varying the pressure you apply gives lighter or darker results. This is particularly pronounced with coloursoft pencils, and it is quick and simple to produce a variety of tones with just one pencil.

To achieve precision with these soft pencils, work away from edges you wish to remain crisp.

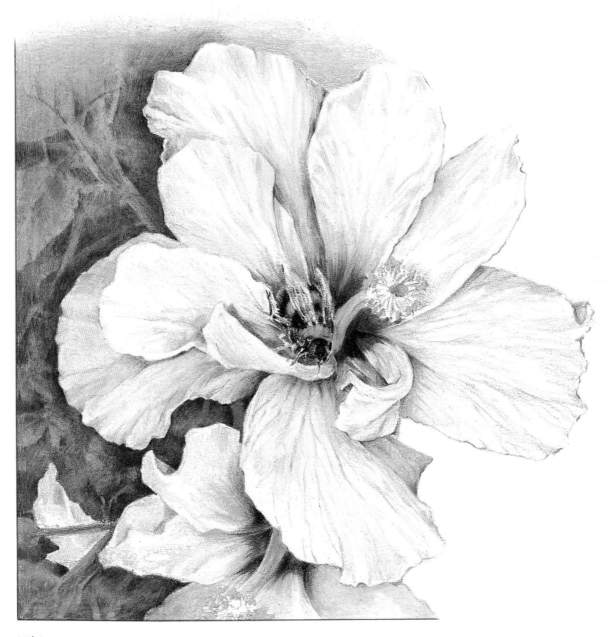

Hibiscus

This flower was worked on card. The coloursoft pencils were blended with the Derwent blender pencil and, in certain areas of the petals, a white pencil.

Flowers like hibiscus have a dark centre, which provides contrast and is an attractive feature in itself. However, you may feel the addition of an insect, as here, will add extra interest and colour contrast.

The unusual format of this image, supported only on one side and at the base, ensures that the delicate light petals are not lost against the richness of a full coloursoft background.

Academy colour pencils

These non-watersoluble pencils are easy to use – they transfer to the paper quickly and evenly and can be blended and overlaid to create a wide range of additional hues. In many ways academy colour pencils are similar to artists' pencils, but they come in a much smaller range of colours – only thirty-six in total. They have a sturdy round casing which is easy to sharpen with a pencil sharpener and the cores are break resistant.

These qualities make them useful if you are on the move or working outside, as it is easier to transport a dozen core colours than a larger number. They also make academy colour pencils an excellent starting range for beginners.

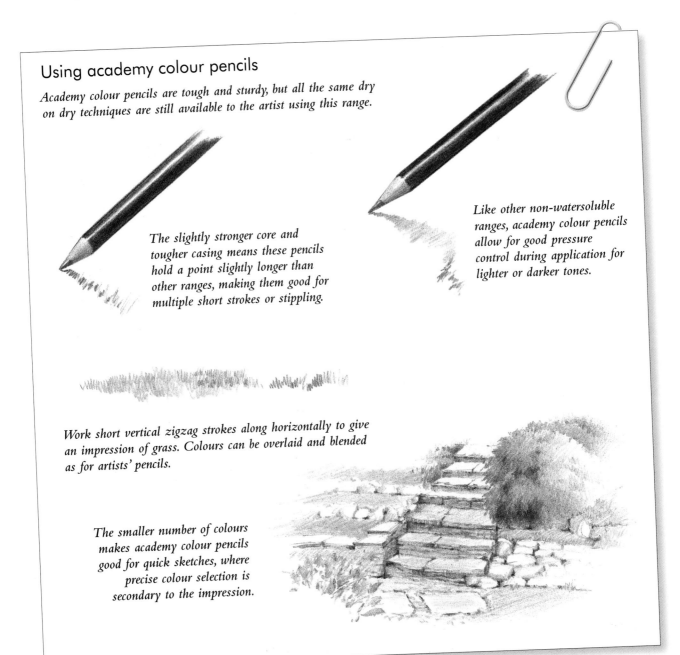

Using academy colour pencils

Academy colour pencils are tough and sturdy, but all the same dry on dry techniques are still available to the artist using this range.

The slightly stronger core and tougher casing means these pencils hold a point slightly longer than other ranges, making them good for multiple short strokes or stippling.

Like other non-watersoluble ranges, academy colour pencils allow for good pressure control during application for lighter or darker tones.

Work short vertical zigzag strokes along horizontally to give an impression of grass. Colours can be overlaid and blended as for artists' pencils.

The smaller number of colours makes academy colour pencils good for quick sketches, where precise colour selection is secondary to the impression.

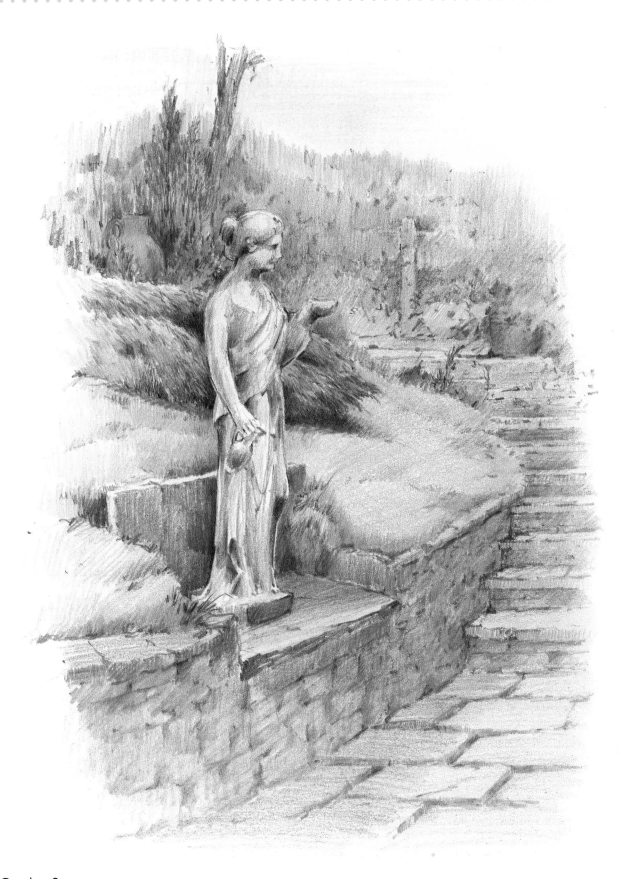

Garden Statue

Worked over a graphite drawing, this colourful corner, in an otherwise neutral garden setting of steps, wall and flagstones, provides a diffused backdrop where we do not need to go into detail.

Academy watercolour pencils

These watersoluble pencils can be used dry, like artists' pencils, or wet which enables you to use a combination of watercolour painting and pencil techniques. The colour blends and dissolves easily once applied to paper, enabling a wide range of additional mixed hues to be created. Alternatively, you can use hues from Derwent's standard watercolour pencil range. These soft-textured pencils have a broader selection of colours and can be used in much the same way as the academy watercolour range.

Water on a brush will lift colour directly from the pencil tip, which can then be used to paint on to dry paper. Alternatively, the paper may be wetted before the academy pencils are used, to produce strong colour with soft edges. The dried colour can be re-wetted if you need to soften or lighten an area.

The core is watersoluble and strong. Academy watercolour pencils are hard enough to be sharpened to a fine point, which will enable you to cut in crisply up to – and work away from – shapes in front. Being easily sharpened and break resistant, they provide an ideal introduction to watersoluble pencil use.

Using academy watercolour pencils

You can use academy pencils dry for both monochrome and colour drawings.

Academy watercolour pencils can be applied in 'blocks' to some spare paper, and then lifted away with a wet brush with which you can paint. This approach creates a swatch of colour for you to use with brush techniques.

You can use a wet brush to blend and draw out dry colour applied to the paper for wet in wet or wash techniques.

You can use a wet brush to lift colour directly from the core of the pencil, and then apply it to the paper with brush techniques.

Simple flower silhouette shapes produced using an academy pencil and a wet brush.

Vary the amount of water used to achieve tonal variety.

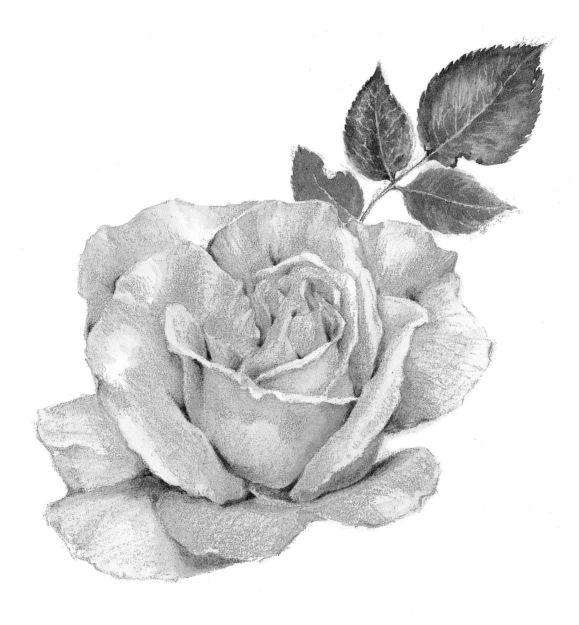

Rose

Roses are such beautiful flowers to draw and paint. Academy watercolour pencils allowed me to create strong contrasts between the highlights of untouched paper and the rich-toned shadow shapes.

Working on cold-pressed Not surface paper, I first drew the image dry on dry. Then a wash of clean water was applied directionally, following the form of the petal shapes before being allowed to dry.

The next step was to redraw, enhancing the fine detail. The point of the pencils allowed me to cut in crisply behind light forms more easily than the brush work necessary with watercolour paint. A careful wash of clean water was then used for the final blending.

Drawing pencils

Drawing pencils, with their exquisite colour range of soft greens, blues and greys, are perfect for life and nature studies. They are also ideal for garden and landscape representations. Due to the number of browns, sepias and greens, they are an excellent range for depicting containers.

The drawing pencils have an extra wide non-watersoluble core which enables you to produce expressive tonal drawings. Owing to the creaminess of the core, the colours mix beautifully when layered on top of each other. This can be enhanced further through the use of a blender pencil (see page 32).

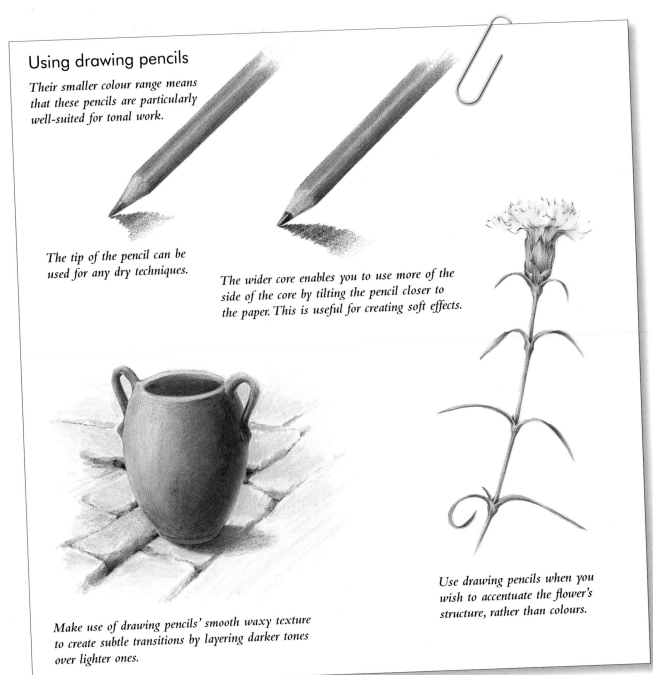

Using drawing pencils

Their smaller colour range means that these pencils are particularly well-suited for tonal work.

The tip of the pencil can be used for any dry techniques.

The wider core enables you to use more of the side of the core by tilting the pencil closer to the paper. This is useful for creating soft effects.

Make use of drawing pencils' smooth waxy texture to create subtle transitions by layering darker tones over lighter ones.

Use drawing pencils when you wish to accentuate the flower's structure, rather than colours.

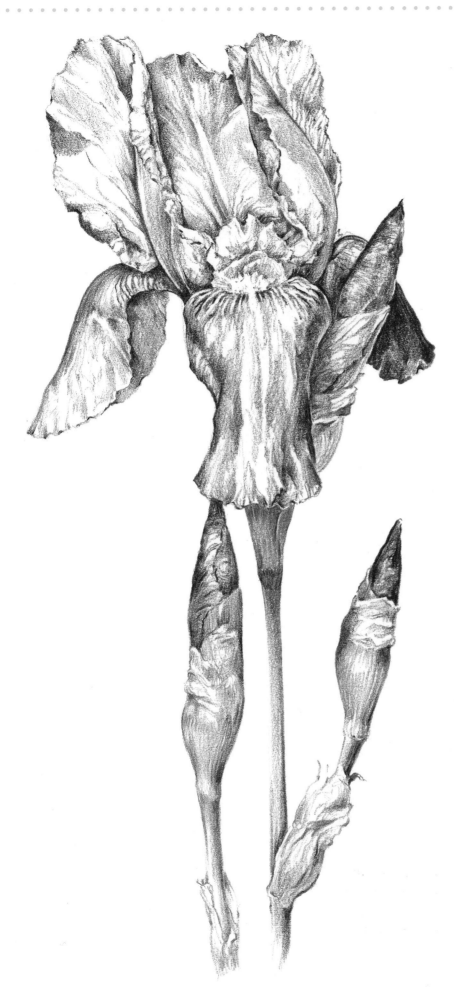

Iris

The drawing pencil range is ideal for monochrome drawings where we can concentrate more upon tonal values using only the one colour or, as I have done here, introduce a hint of other hues.

There are numerous varieties of iris for us to draw and paint and you can see my painting of a blue variety on page 121. There is also a vast choice of colour including yellow, purple and bronze – as well as white iris.

Inktense pencils

Inktense pencils are watersoluble, with a core that behaves like traditional ink when wetted. This means that they can be used dry for detailed botanical work or washed out with a little water to create vivid translucent effects that are more vibrant than the academy watercolour pencils.

They differ from the academy watercolour range in that once dry, the colour is fixed permanently. As a result, working with inktense pencils should be planned especially carefully as colour can not be removed later. However, it also means that inktense work can be worked over with other media later, offering a range of possibilities for rich floral work.

The range includes a non-soluble outliner pencil. Like the others in the range, it is permanent, which means it can be used to draw an initial sketch over which washes are placed. This outline will remain visible, as shown in the examples on pages 81 and 83.

Fixing inktense pencils

Having placed your artwork in inktense pencil, you can gently wash clean water over all the dry drawing to blend and 'fix' the colour in place permanently.

Use brushstrokes that follow the same direction as the pencil marks to avoid disrupting the pencil work.

This is not necessary with the other watersoluble pencils as they are not permanent.

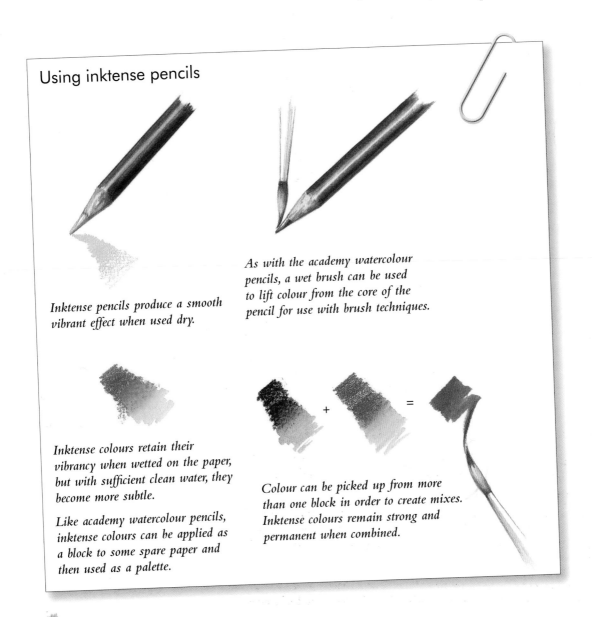

Using inktense pencils

Inktense pencils produce a smooth vibrant effect when used dry.

As with the academy watercolour pencils, a wet brush can be used to lift colour from the core of the pencil for use with brush techniques.

Inktense colours retain their vibrancy when wetted on the paper, but with sufficient clean water, they become more subtle.

Like academy watercolour pencils, inktense colours can be applied as a block to some spare paper and then used as a palette.

Colour can be picked up from more than one block in order to create mixes. Inktense colours remain strong and permanent when combined.

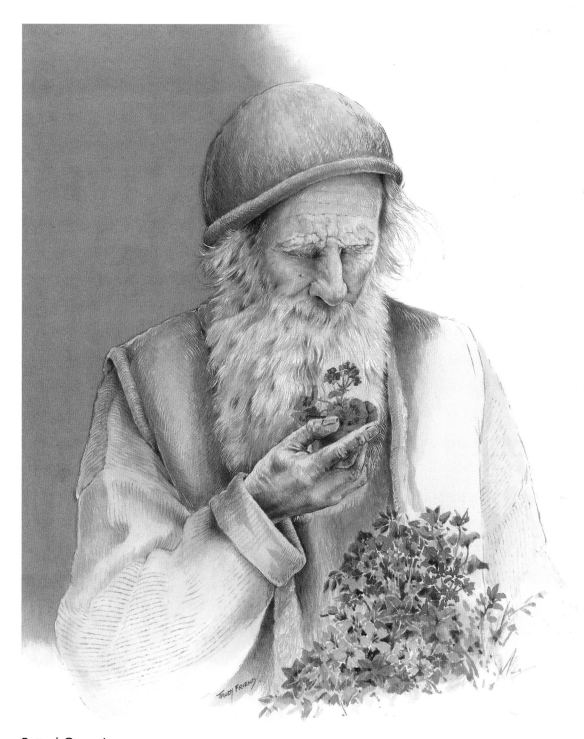

Potted Geraniums

The vibrant hues of inktense pencils can also be used for subtle colour washes over neutral representations, as shown in this drawing, worked upon Saunders Waterford cold-pressed (Not) paper.

Detailed drawing with the brush using blocks of inktense pencils has been overlaid with translucent glazes of inktense colour for the figure. Stronger, more solid colour has enabled the pot of flowers in his hand, and those arranged in the foreground, to stand forward.

At the top left-hand corner, I have demonstrated how washes made from these pencils can cover the paper evenly and vignette out, rather than fill the entire background.

Aquatone paint sticks

These 'pencils' have no casing. Instead, the stick is made of solid watercolour paint, with a protective paper wrapping. Aquatone sticks are identical to the core of the watercolour pencils, which means they may be used wet or dry in the same way as the pencils, and the colour ranges are identical. This makes them useful in combination – using the watercolour pencils for detail and the paint sticks for larger areas of colour.

The aquatone sticks are slightly less user friendly than cased pencils as they are slightly more fragile and messy, but they offer some useful and unique techniques, as well as pure speed of use.

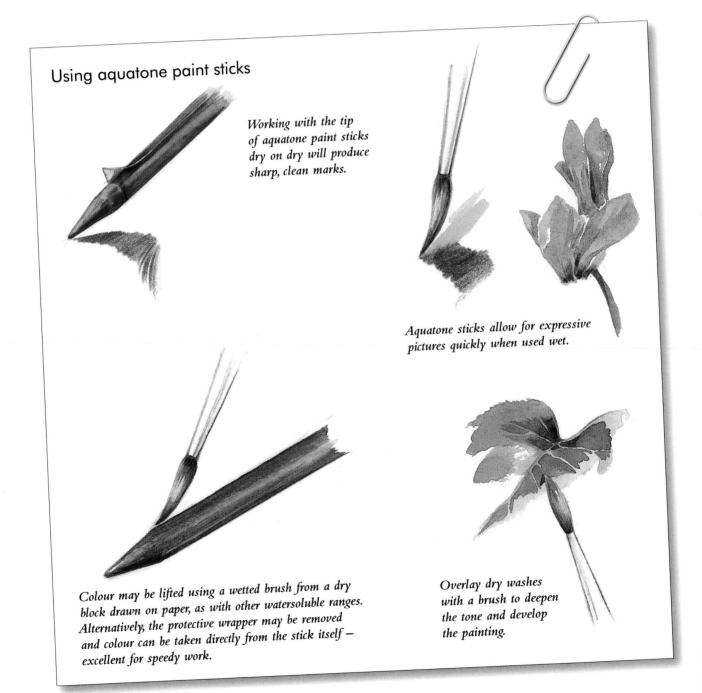

Using aquatone paint sticks

Working with the tip of aquatone paint sticks dry on dry will produce sharp, clean marks.

Aquatone sticks allow for expressive pictures quickly when used wet.

Colour may be lifted using a wetted brush from a dry block drawn on paper, as with other watersoluble ranges. Alternatively, the protective wrapper may be removed and colour can be taken directly from the stick itself – excellent for speedy work.

Overlay dry washes with a brush to deepen the tone and develop the painting.

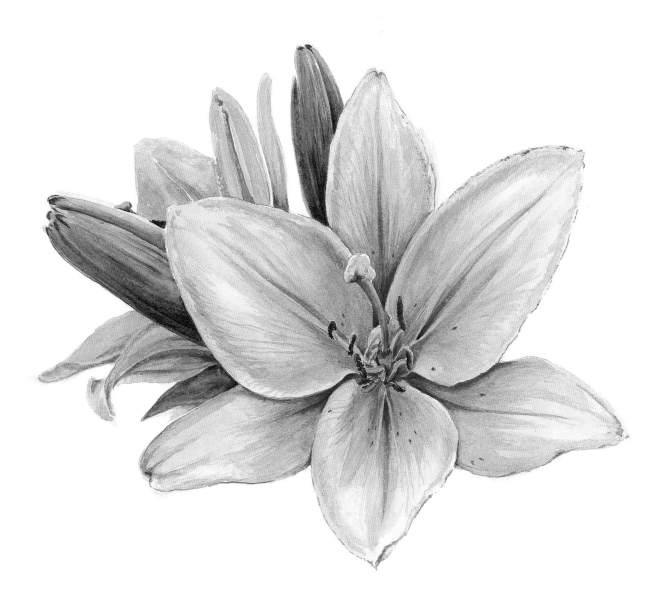

Lily

The graduating hues and tones lead our eye towards areas of highlight in the central area of this lily, and these subtle transitions culminate in 'broken line' edges. These, along with crisp contrasts – where light petal edges cross in front of the darker shadows in recessed areas – give drama to a study where we see only a limited area of the form. Lily trumpets are usually more recognisable when viewed from the side.

Aquatone paint sticks are perfect for the technique of overlaid washes used for painting this lily, owing to their speed of use. The technique is explored in more detail on page 97.

Graphitint pencils

Graphitint pencils have watersoluble cores. When applied dry, they appear fairly muted, with just a hint of soft, subtle colour. With the addition of water, the area can be selectively developed into a rich, vibrant wash.

Ideal for landscape and portrait studies, there are some tints in this range that are perfect for certain flowers and leaves, while containers, walls, pathways and similar subjects benefit from these subtle hues.

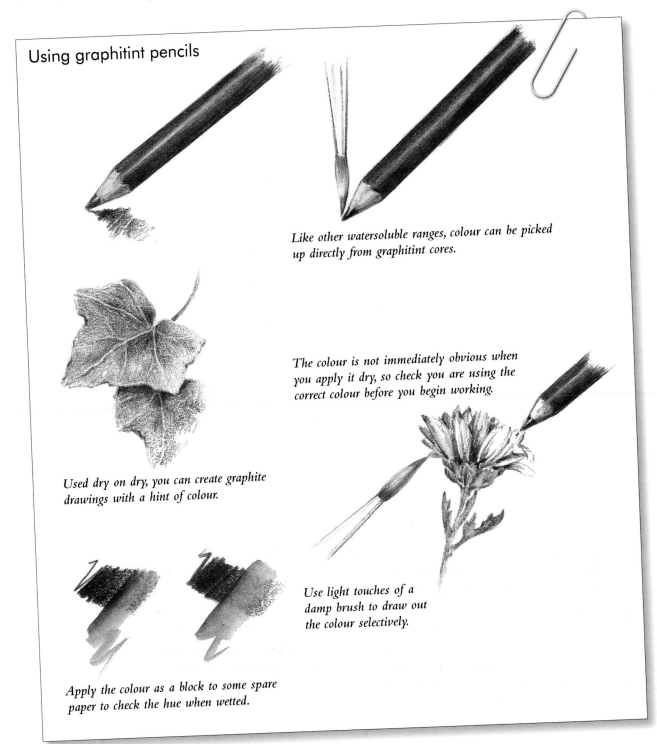

Using graphitint pencils

Like other watersoluble ranges, colour can be picked up directly from graphitint cores.

The colour is not immediately obvious when you apply it dry, so check you are using the correct colour before you begin working.

Used dry on dry, you can create graphite drawings with a hint of colour.

Use light touches of a damp brush to draw out the colour selectively.

Apply the colour as a block to some spare paper to check the hue when wetted.

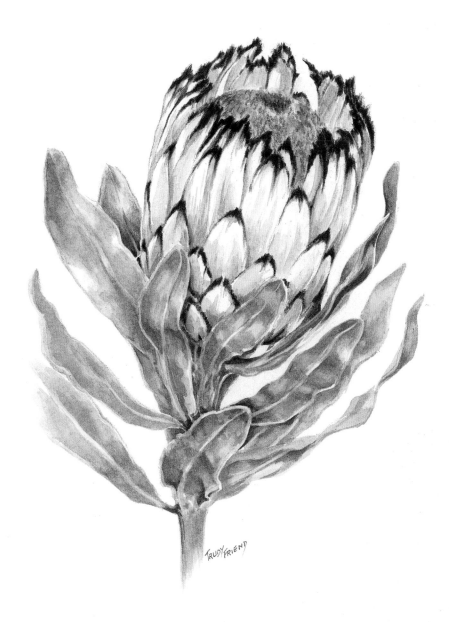

Cape Artichoke

Flowers like this cape artichoke (also called king protea) require subtle hues for their depiction and graphitint have the requisite soft qualities, especially when the image is first drawn upon hot-pressed paper and then touched with a brush dipped in water.

The feathery edges were first drawn in the colour port before a damp brush was used to blend the pigment. I then used midnight black pencil, sharpened to a fine point, to enrich the effect.

Attaching an offcut of watercolour paper to my board to use as a palette, I made swatches of the other colours, touching each with water to blend or mix in order to paint pale underlays and eventually the final contrasts. I often use this method, rather than a plastic or ceramic palette, when painting small areas.

Pastel pencils

Pastels are pure pigment suspended in a binder. They are naturally very soft and powdery, which can make them a little difficult to control. This range of pencils uses pastels as the core and cases them in wood, which makes them more easy to manage when drawing detailed flowers, but still allows you to produce the distinctive finishes of pastels – velvety smooth or more textured, depending upon the support you use.

Pastel pencils are naturally watersoluble, which makes them fantastic for mixing and blending when wet. Used dry, these pencils are ideal for crisp, fine lines. Detailed pastel studies and colours may be layered on top of each other to create new tints and hues.

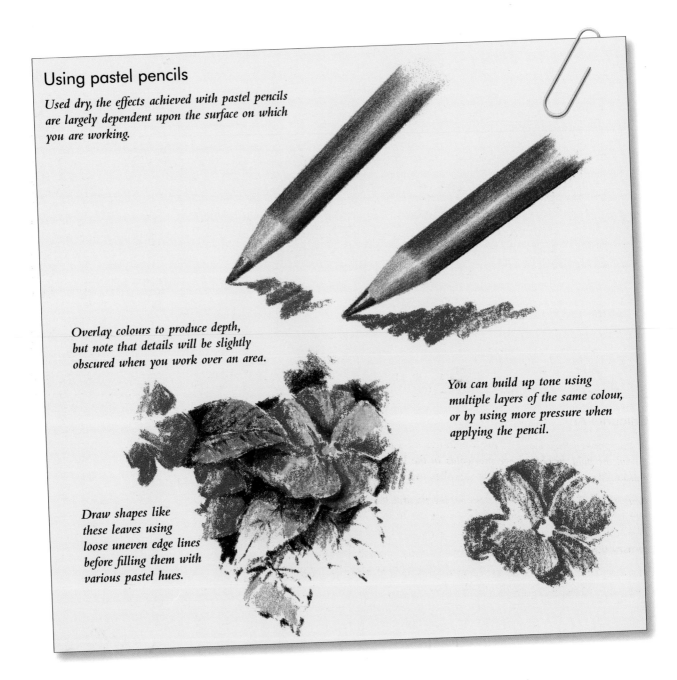

Using pastel pencils

Used dry, the effects achieved with pastel pencils are largely dependent upon the surface on which you are working.

Overlay colours to produce depth, but note that details will be slightly obscured when you work over an area.

You can build up tone using multiple layers of the same colour, or by using more pressure when applying the pencil.

Draw shapes like these leaves using loose uneven edge lines before filling them with various pastel hues.

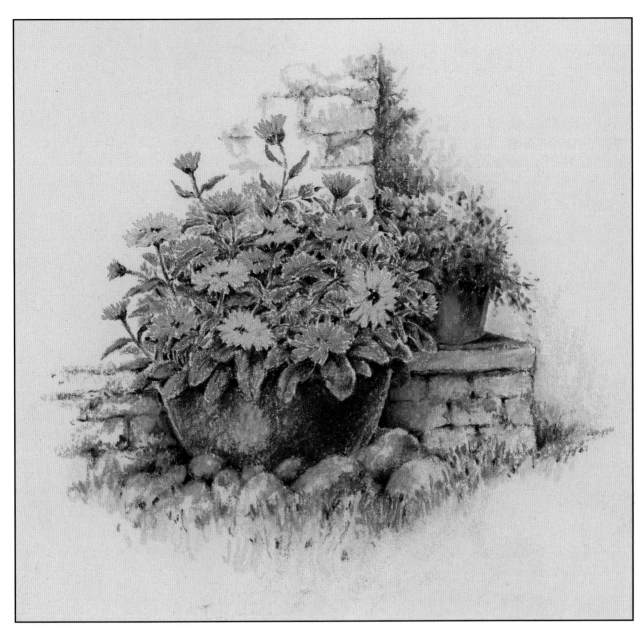

Colourful Arrangement

In this pastel pencil study of two containers with plants, you can see that I placed the bold, bright orange marigolds in the larger blue container and the delicate blue trailing flowers in the smaller, warm colour of a terracotta pot.

With these contrasting vibrant colours, the natural hues of step, wall and stones were all that was needed to support the study. The greens of the grass and background foliage could therefore be limited in order to keep our eye focused upon the main areas of interest.

Working on a tinted cold-pressed paper, I was able to make use of white pastel pencil for highlights on the small blue flowers.

Water brushes

Water brushes, also known as brush pens, have plastic barrels with a nylon-tipped brush on a detachable end. Once the barrel is filled using a pipette (see below), it can be squeezed gently to push water into the brush end, which can then be used to apply water exactly like a paintbrush. Using more pressure increases the water flow. Water brushes can be purchased in packs of mixed tip sizes – broad, medium and fine.

Colour washes

Instead of clean water, water brushes can be filled with a coloured solution made from the shavings of watersoluble pencils and used to apply colour directly. To prepare a colour wash, pare back the wood casing from one of your watersoluble pencils using a utility knife, then sharpen the core directly into the well of a palette. This can then be mixed with water to be used as an instant wash. A pipette can then be used to take up the mix and fill the barrel as normal. When the end is screwed firmly back in place, you can paint as if using a normal paintbrush.

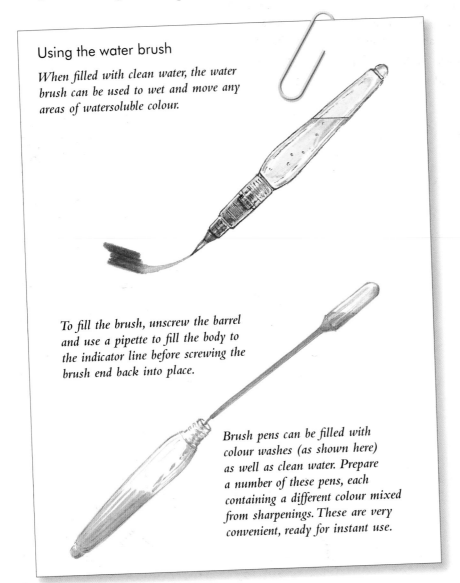

Using the water brush

When filled with clean water, the water brush can be used to wet and move any areas of watersoluble colour.

To fill the brush, unscrew the barrel and use a pipette to fill the body to the indicator line before screwing the brush end back into place.

Brush pens can be filled with colour washes (as shown here) as well as clean water. Prepare a number of these pens, each containing a different colour mixed from sharpenings. These are very convenient, ready for instant use.

Papers

There are three main textures of watercolour paper. The most useful for drawing flowers are the smooth hot-pressed (HP) and the medium cold-pressed (CP), also known as 'Not' surfaces. The cold-pressed sheet is very versatile, whilst the hot-pressed is best suited to detailed works, making it ideal for flowers. Watercolour paper is also available in a rough surface, which is less suited to drawing flowers.

The background tint of the paper makes a big impact on the overall composition of the work. A Saunders Waterford high white or a Bockingford white paper will give a bright contrast between the flower and the background whiteness of the sheet, giving a clean, contemporary look, while the creamier shade of Saunders Waterford's white will give the drawing a warmer feel. Bockingford paper also comes in some exciting light tints with a cool eggshell, blue and grey plus warm cream and oatmeal shades, which are superb for adding instant atmosphere.

Buying watercolour paper by loose sheets is the most economical way to purchase good paper. Standard size sheets are quite large at 56 x 76cm (22 x 30in) but these can be torn down into small sizes. There are also blocks of paper that have glued edges on all four sides, which eliminates the need to soak and stretch the sheet as the paper dries flat if you apply a wash prior to your drawing.

Alternatively, paper comes in a variety of smaller pads and spiral sketch books, which stops the artist being faced with a daunting large sheet of blank paper.

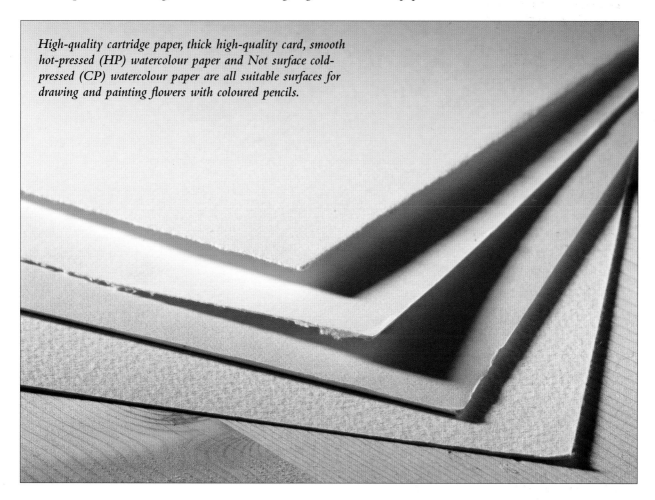

High-quality cartridge paper, thick high-quality card, smooth hot-pressed (HP) watercolour paper and Not surface cold-pressed (CP) watercolour paper are all suitable surfaces for drawing and painting flowers with coloured pencils.

Using different papers

The surface texture and tint of the paper surface you use can influence the results of the pencil range or ranges that you use. These pages show a few examples of flowers created upon some different ranges of papers using various techniques.

Dry studio pencils on dry Bockingford cold-pressed white paper

Although ideal for detailed illustrations when used upon a smooth surface, you can achieve a slightly embossed effect with studio pencils by working with firm pressure upon this cold-pressed textured paper.

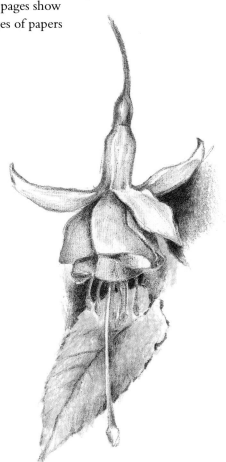

The slight texture of cold-pressed paper influences the effect created when pencils are gently layered.

You will need to apply firmer pressure upon your pencil for more solid darks upon cold-pressed paper.

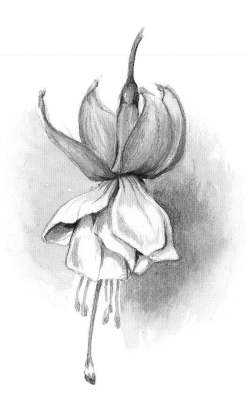

Wet inktense pencils on dry Bockingford cold-pressed white paper

The vibrant colours of inktense pencils work well upon this versatile cold-pressed surface, and even very pale background hues will allow white petals to stand forward when used on this pure white paper.

Dry coloursoft pencils on dry Saunders Waterford cold-pressed high white paper

Coloursoft pencils, when used upon this paper, enable you to depict strong bold images of delicate blooms. White coloursoft pencil has been overlaid to blend colours while also enhancing the highlights.

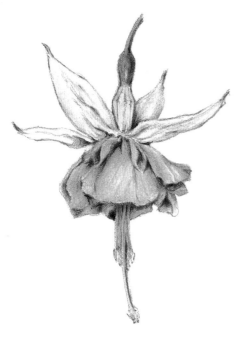

Wet inktense pencils on dry Saunders Waterford cold-pressed high white paper

The jewel-like colours from the inktense range have the vibrancy of ink and contrast beautifully against the white surface of this paper. It is an ideal surface for fluid brushwork.

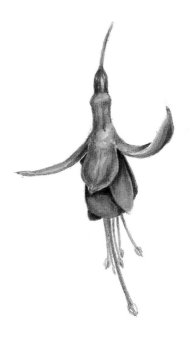

Dry academy watercolour pencils on dry Saunders Waterford hot-pressed high white paper

This paper enables smooth applications, achieving subtle contrasts. When used dry on dry, academy watercolour pencils pair well to a smooth hot-pressed surface.

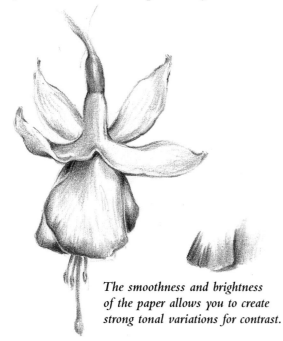

The smoothness and brightness of the paper allows you to create strong tonal variations for contrast.

Wet academy watercolour pencils on dry Saunders Waterford hot-pressed high white paper

Used wet on the smooth dry surface of this hot-pressed paper, academy watercolour pencils allow fluid brushwork to be achieved.

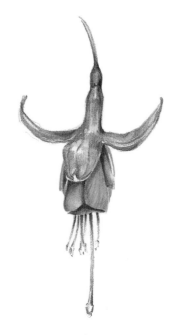

Other materials

Brushes

For the illustrations and demonstrations in this book I have used synthetic brushes as I find they hold paint well, have useful 'spring' and keep their shape. Used and stored with care, they last for a considerable time. I also find I can, by gently pressing it against the palette, make a round brush into a flat shape that produces fine lines when required.

I usually use just three sizes – a 3 or 4, a 6, and an 8 – for paintings of around 216 x 292mm (8½ x 11½in) size. For larger works and more extensive washes the larger sizes are essential. However, even these may be used for fine detail as long as they form to a good point. A liner-writer brush is an especially fine brush with a good point. As the name suggests, it is very useful for fine lines.

Sponge

Imprints from a sponge dipped in washes made from watersoluble pencil and water mixes can provide interesting textural effects upon which to build overlays. Massed foliage impressions or textured stonework, for example, can be based upon this underpainting technique. Areas of a painting that have received too much pigment may be sponged off or softened with the use of this material.

Water pots

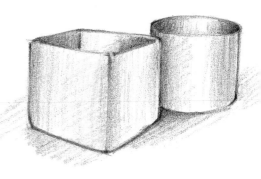

Water pots can be of any shape or size according to personal needs and it is helpful to have two in use while you work – one for rinsing pigment from brushes and the other to collect clean water on the brush to mix a new colour. Some water pots have a rim with a series of holes and a drip tray beneath. This is the type I use as it allows me to place the brushes with hairs facing towards the tray, preserving their shape while in use.

Burnisher pencil

With a core made from a hard colourless wax, the burnisher pencil can be rubbed firmly over layers of pigment. This has the effect of pushing the pigment into the paper, leaving a well blended, photograph-like finish. Burnishing your work makes it look polished and brightens the appearance of the colours.

> **Tip**
> Derwent's burnisher and blender pack, with eraser and pencil sharpener included, is a useful addition to an accessory supply.

Pencil sharpeners

Derwent's pastel pencil sharpener is a useful tool available especially for sharpening these softer pencils. There are many varieties of pencil sharpener in both plastic and metal – single and dual – to accommodate both wide and narrow barrels.

Utility knife

A good quality utility knife – with the blade frequently replaced – is excellent for sharpening all varieties of colour pencils. It is especially useful with the watersoluble ranges to create colour washes, as described on page 28. I have a large plastic palette with many small wells into which I have sharpened a series of inktense colours ready mixed for future use in the same way as a watercolour pan box.

Angled board

Apart from the occasions when I need to work with paper flat upon a table to achieve certain effects, I always work at an angled board. The angle at which I have the board will vary both for comfort and for practical reasons: I will use a more acute angle for looser, watersoluble pencil washes than when using dry pencils for close detailed work. An adjustable easel is a useful luxury, but a simple board may be propped on a box of the appropriate height for the angle at which you wish it to rest.

Masking tape

Whether working at an angled board with a slim ledge at the base to prevent paper from slipping off, or on a board that has no ledge, I use small pieces of masking tape to hold paper in place. This tape is also useful when tracing over the preliminary drawing at a window (instead of a light box) to hold both the sketch and other paper in place.

Techniques

This chapter explains how to use the ranges of pencils and other materials described earlier to draw and paint flowers. Some are specific to a particular range or material, but most are general techniques that allow for different effects.

The most fundamental techniques are the six basic strokes I use for all dry and watersoluble applications, but this chapter also covers glazing, using masking fluid, brushwork and creating washes of colour, blending, creating texture with watersoluble media, and how best to combine your watersoluble pencils with other materials for mixed media work.

At the end of this chapter, I have also explained the importance of recognising negative shapes, the way choice of format can help in the presentation of artworks, and – perhaps most importantly – how to get started with your flower paintings.

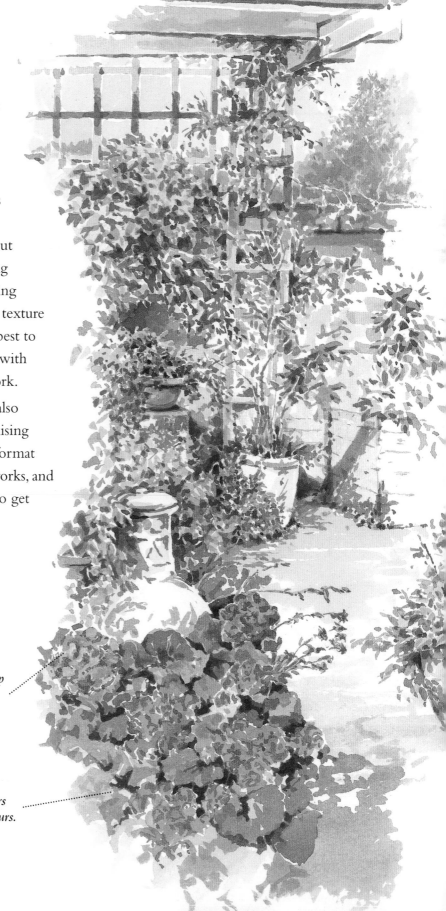

These flowers are built up through tonal overlaying of simple shapes.

Glazing over earlier layers helps produce strong colours.

34

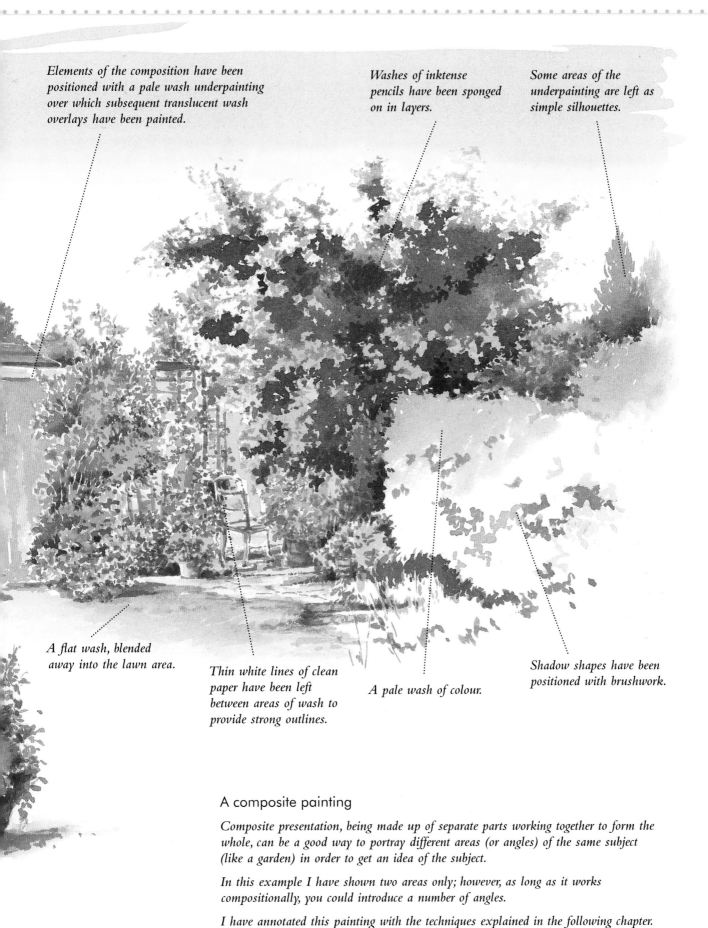

Elements of the composition have been positioned with a pale wash underpainting over which subsequent translucent wash overlays have been painted.

Washes of inktense pencils have been sponged on in layers.

Some areas of the underpainting are left as simple silhouettes.

A flat wash, blended away into the lawn area.

Thin white lines of clean paper have been left between areas of wash to provide strong outlines.

A pale wash of colour.

Shadow shapes have been positioned with brushwork.

A composite painting

Composite presentation, being made up of separate parts working together to form the whole, can be a good way to portray different areas (or angles) of the same subject (like a garden) in order to get an idea of the subject.

In this example I have shown two areas only; however, as long as it works compositionally, you could introduce a number of angles.

I have annotated this painting with the techniques explained in the following chapter.

Basic strokes

I use only six basic stroke applications, and combinations of these six strokes throughout this book. These elementary strokes are described and illustrated in isolation on this page and shown in use in the picture opposite.

• By varying the pressure placed upon the pencil, you can achieve interest of line and variety of tone in your flowers.

• When toning flat areas, parallel lines create an area of tone that may have different values, depending upon the amount of pressure you place upon the pencil. You can also increase intensity of tone by overlaying one layer upon another. For contoured surfaces you need only curve your parallel line strokes to follow the form.

• As there is a crispness to many leaf edges and flower petals, we can see angles in these parts. For these a zigzag application of strokes can lay the foundation of massed foliage effects.

• We often see flowers and foliage in the form of dark silhouette shapes and, in these cases, a crossover movement of the pencil will give the desired impression.

• Supporting backgrounds like walls may be depicted using a twisting stroke movement, that brings different parts of the pencil tip in contact with the surface. This is useful for creating interesting shadow lines in roots, branches, stems or within stonework.

• Stippling – marking the paper surface with dots or short push strokes – creates surface texture useful for some rock formations and man-made concrete mixtures. This technique is particularly effective on textured paper.

Varied pressure

Press firmly on the pencil then lift away a little, to create interest in lines showing the edge of a leaf or petal shape.

Crossover

Use strokes that mass and cross over each other to create the effect of small leaves upon trailing stems.

Parallel lines

These lines indicate a flat surface. Space them more widely for lighter tones and place them close together for darker areas of tone.

Twisting

Twist the pencil in order to use the wider chisel side of the core and then the narrow side to create variety of line and tone.

Zigzags

Use continuous pencil strokes of varied pressure and width to form the basis for massed foliage and flowers.

Stippling

Whether using the surface texture of your paper as a guide, or a series of dots, stippling allows you to create interesting textural effects.

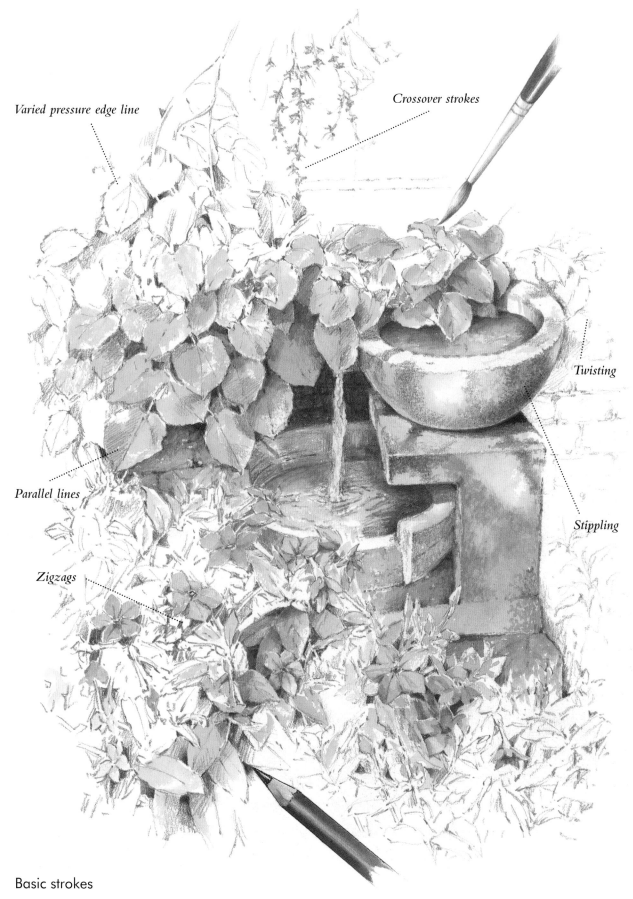

Varied pressure edge line

Crossover strokes

Twisting

Parallel lines

Stippling

Zigzags

Basic strokes

This picture incorporates all six of the basic strokes.

Brush techniques

Whether using a water brush or a normal paintbrush, these techniques will help you to create convincing flowers using a combination of traditional watercolour painting techniques and the pencil techniques described earlier.

All of these techniques rely on diluted solutions of watersoluble pencil shavings, as described on page 28. I use solutions made from inktense pencils most often for these techniques.

Drawing with the brush

The most basic brush technique is to use the water brush exactly as you would a watercolour pencil, building the image up gradually from a lighter beginning to a stronger finish by laying new layers on top of dry ones.

First stage
Using the water brush like a pencil, the basic shape is painted in the palest tone of the appropriate colour.

Second stage
Once the shape is dry, use the same hue to intensify the image and begin to build areas of tone.

Third stage
Additional shapes, like the stem here, can then be drawn in using a water brush filled with a different colour.

As you build up from simple shapes into more complex pieces, these other brushwork techniques will become useful.

• Cutting in – This is the technique of taking the brush into an area to leave a sharp, clean edge. Cut in with a darker colour to bring light forms forward.

• Leaving crisp edges – A slim strip of untouched paper around the edges of flowers will create a crispness to your painting. This is simple to achieve with brush drawing as long as you ensure the underlying colours are dry.

• Wet in wet – Colours will be muted if the next layer is applied wet in wet, or before the underlying colour is completely dry.

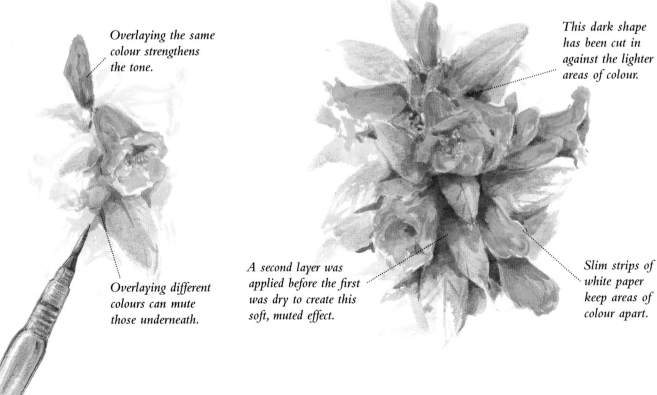

Overlaying the same colour strengthens the tone.

Overlaying different colours can mute those underneath.

A second layer was applied before the first was dry to create this soft, muted effect.

This dark shape has been cut in against the lighter areas of colour.

Slim strips of white paper keep areas of colour apart.

Flat washes

Washes will be familiar to any watercolour artist. They are simply watery paint applied over an area to fill it with a uniform colour. Flat washes are the basis of many other techniques, including overlaying and glazing.

You can use a paintbrush to apply a wash using your diluted solution of watercolour pencil shavings. Use a brush with good fluid-carrying capacity for the initial wash so that you do not need to reload it repeatedly, as this can lead to an uneven finish.

Alternatively, by filling a water brush with the watersoluble pencil solution, you can apply an initial flat wash with the control of a pen.

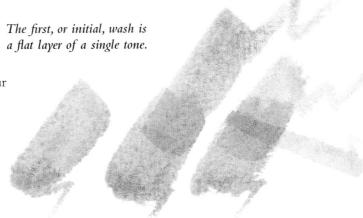

The first, or initial, wash is a flat layer of a single tone.

Once dry, an overlaid second wash of the same colour will increase the tone.

You can gradually darken the tone with subsequent overlaying washes.

Overlaying washes

If you allow a wash to dry, you can lay a subsequent wash over the top of it – either in part, or completely covering it. Each time a wash is overlaid the strength of tone will increase. This allows you to build up the strength and tone of the colour, as shown above right.

You can also overlay a dry wash with another colour. Practise your colour overlays before you start so that you understand how the colours will change when other hues are painted over it.

Overlaying washes is an exciting way to achieve three-dimensional effects by building contrasts. You can vary the intensity of the mixes to suit your subjects and by overlaying, wet on dry, will be able to build your painting.

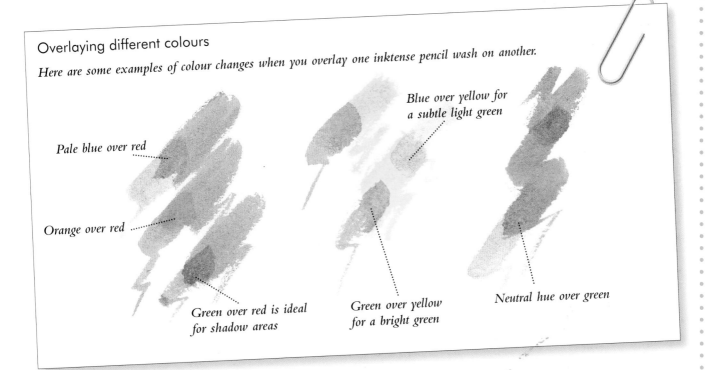

Overlaying different colours

Here are some examples of colour changes when you overlay one inktense pencil wash on another.

Pale blue over red

Orange over red

Green over red is ideal for shadow areas

Blue over yellow for a subtle light green

Green over yellow for a bright green

Neutral hue over green

Pen and ink

You can create the impression of a pen and ink study by using a fine liner-writer brush with a good point with which to draw using a colour wash (see page 28) of a fluid ink-like consistency.

If you wish to achieve delicacy with this technique, practice is essential; you can then make your mistakes and discover the potential of this medium before embarking on your final artwork. The examples on this page were made using a fine-tipped liner-writer brush and ink black inktense pencil. Sepia is a good alternative colour to try.

Brush drawing exercises

Using the very tip of the brush, draw a series of vertical parallel lines.

Vary the distance between the lines.

Vary the length of lines and the pressure you place upon the brush to achieve different tonal effects.

Practise vertical and horizontal lines, varying the pressure placed on the brush to familiarise yourself with the brush's potential.

More pressure results in thicker areas on the line.

Draw multiple short strokes in different directions to suggest flowers and foliage.

Vary the pressure to achieve interesting leaf and grass shapes. Draw the brush in the direction of growth for clean lines.

Pull down strokes in different directions for longer leaves, and use crisscross strokes to suggest shadow shapes between leaves.

Brush drawing

This panoramic brush drawing has been made using only two watercolour pencils – willow and light olive – and a liner-writer brush. The brown colour is made with a mix of the other two.

Hanging Basket and Climbing Plants

This study has been drawn using ink black inktense pencil and a fine brush on cold-pressed Not surface high white paper. I find that the texture of this surface helps the brush create interesting marks.

Using masking fluid

Masking fluid can be very helpful when you wish to portray white or pale forms against a busy tonal or colourful background. These pages show an example of how to use masking fluid. I have shown six stages of development that may be used in order to build a painting where white petals create impact against a darker background.

Planning

It is important to plan the composition of your painting before you apply any masking fluid because you must consider the light areas, which need to remain clean of paint before you begin. You can then add the investigative drawing (the first stage below).

Applying masking fluid

With the simple outlines in place upon the paper, paint the masking fluid over areas that are to be retained as white paper and those over which clear, pale colours will be painted – in the example below, the clover heads. Use an old brush to apply the masking fluid, being careful to wash and dry it during and after use to avoid clogging it with dry fluid.

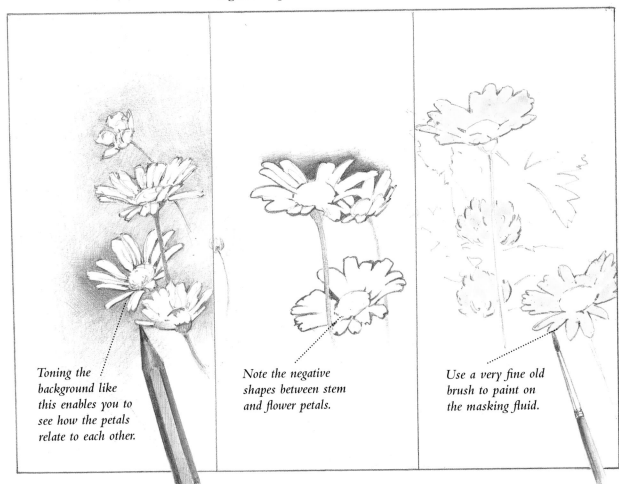

First stage

Investigative drawing is used to position the flowers.

Second stage

Relationships between the shapes are developed by enhancing the negative shapes around them.

Third stage

Masking fluid is painted over all of the areas to be retained as clean white paper.

Toning the background like this enables you to see how the petals relate to each other.

Note the negative shapes between stem and flower petals.

Use a very fine old brush to paint on the masking fluid.

Working with masking fluid

When masked areas are thoroughly dry you can either paint a wash of base colour, as I have shown in the example below, or use wet in wet techniques for a colourful and varied diffused background effect.

Make sure the wash – in this case one that has been mixed using inktense pencils – is thoroughly dry before gently removing the masking fluid.

I like to depict a suggestion of massed foliage with regard for tonal shapes, without going into detail, for the background area, and I am careful not to trespass over and into any of the white paper shapes. It is important to cut in crisply around these.

The final stage consists of enhancing dark tonal shapes in the background, especially those against the crisp, white petals where maximum contrast creates drama. While working in this way you can also add colour to the main forms, like the centre of the flowers and the clover heads.

Toning the background like this will enable you to see how flower petals relate to each other.

Fourth stage

A colour wash is applied over the whole area and allowed to dry. The masking fluid is then removed.

Fifth stage

The impression of background foliage is created with various tones of green applied loosely.

Sixth stage

Finally the painting is built up with overlaid washes in the background and detail in the flower heads.

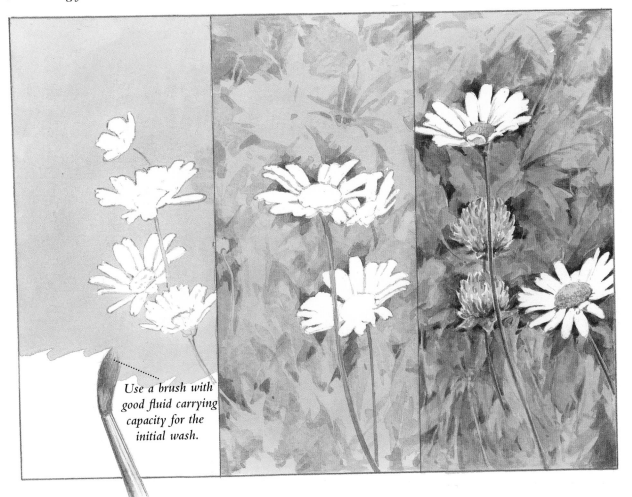

Use a brush with good fluid carrying capacity for the initial wash.

Blending

Whether using dry or watersoluble pencils, there are times when we wish to achieve a gradual transition from one hue or tone to another for a soft effect. This is called blending.

All the pencil ranges I have used for this book are suitable for blending – even if in different ways (for various effects) as long as the paper's surface is conducive to the techniques used. This is why I have chosen to use the papers explained on pages 30 and 31.

Wet in wet

Blending colours wet in wet may involve wetting the whole paper surface and keeping it damp enough to allow the colours to flow into each other. Alternatively only certain specific areas are dampened in order to blend the colours there together, while the remainder of the picture is left dry. This allows you to retain crisp edges to petals, for example. You can wet the paper with a damp brush or a water brush, and gently stroke the colours into one another. You can follow the direction of the underlying pencil strokes to keep the impression of direction.

When producing a vignette study, such as those shown here, we are blending out into untouched paper, which requires such smooth blending that we are unable to see where the transition takes place.

When using inktense washes it must be remembered that they are permanent once dry. This means that it is not possible to soften hard edges that are not required, with a sponge or brush – as we can with other watersoluble pencil ranges.

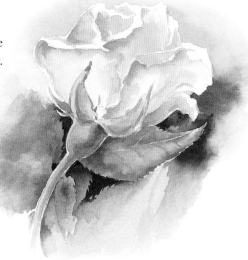

This small example shows washes of inktense colours blended wet in wet. The washes were diffused into the background by wetting the area, while the rose itself was left dry in order to keep it clear and strong.

Wet in wet blending can be combined with masking fluid to produce a soft background. Here, a wash has been laid over dry masking fluid. When dry, the masking fluid was gently removed to reveal clean paper, which can then be painted as normal.

Controlled wet in wet blending can give a loose, fluid impression even to small areas like these flowers.

Dry on dry

When blending dry pencils on dry paper, a blender pencil – which is soft and colourless – is rubbed over an area of layered pencil colour to combine them for a smooth effect.

The effects achieved will depend upon the surface upon which you have chosen to work. A smooth surface will let the colours blend very evenly and smoothly. On a textured paper, pressing lightly with the blender pencil will leave some gaps and spaces where the underlying colour will show through for an interesting effect (see page 87 for an example). In areas where smooth blending is required, press more firmly on textured paper to reduce this effect.

I tend to use the non-watersoluble pencil ranges for this technique, although the watersoluble ones may be used if they are the only ones you have. The lovely creamy, extra-wide strip of the drawing pencils is ideal for smooth blending with a blender pencil and will enable you to achieve subtle transitions.

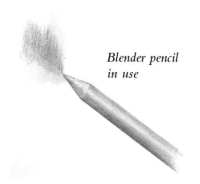

Blender pencil in use

Tip

Solvents, such as the brush cleaner turpenoid natural, may be used on dry blended areas to soften the effect even more.

The indistinct background impression that supports the main images of this example is suggested using dry on dry blending. I worked with coloursoft pencils on smooth hot-pressed paper.

First stage

The main shapes like flowers and stems are positioned with light drawing.

Second stage

Hue and tone are built through layering other colours on top of the first stages.

Third stage

The gently overlaid colours are blended together using a blender pencil.

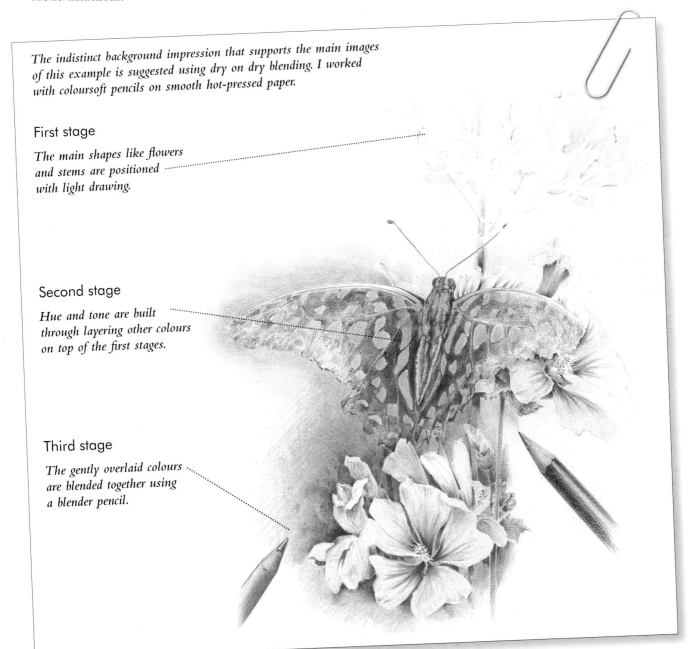

Glazing

Glazing is a watercolour painting technique that involves laying a very diluted wash of almost transparent pigment over dry light hues to tint the wash or image beneath in order to create richness and luminosity. The technique is similar to overlaying, but uses much more dilute washes.

Glazing washes may be laid flat upon dampened paper in broad areas and may also be applied to small areas using short brushstrokes wet on dry. The latter will add vibrancy to small components.

A monochrome watercolour painting can be transformed by overlaying it with glazes of different colours. Each of the small colour paintings below started as underpaintings similar to the monochrome detail at the top left. Glazing washes of different hues, indicated by the nearby swatches, have been glazed over each underpainting. Notice how different hues can give strikingly different results from each other.

Adding new colour into darks and glazing over light hues and/or white paper produces interesting effects.

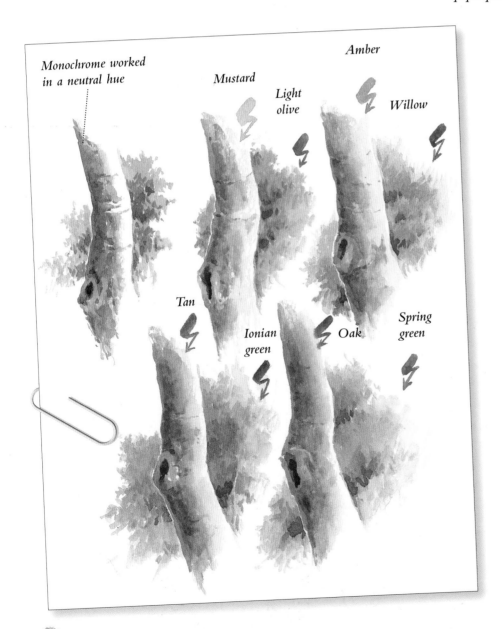

Monochrome worked in a neutral hue

Mustard

Amber

Light olive

Willow

Tan

Ionian green

Oak

Spring green

Using glazes in your work

The example below shows the four main stages of development of a painting that includes glazing as a technique. This subtle but important technique brightens the study by overlaying a final glazing wash of inktense sun yellow pigment.

First stage: Drawing (1)

My initial drawing was made dry on dry using the six basic strokes with green and orange watercolour pencils.

Second stage: Washes (2)

I dipped a brush in clean water to blend the dry pigment into the paper using sweeping strokes over the flower shapes.

For the leaves I mixed sharpenings from my pencil with water in a palette well and washed this over the drawing to fill the shapes.

Third stage: Blending (3)

Some areas, presented as a vignette, were blended out into the paper with varied direction stroke application.

Fourth stage: Glazing (4)

Diluted pigment from sun yellow inktense pencil was glazed over both orange and green areas.

However, as the flowers are also yellow in certain areas, by painting over untouched paper, yellow areas were established, leaving only the tips as white.

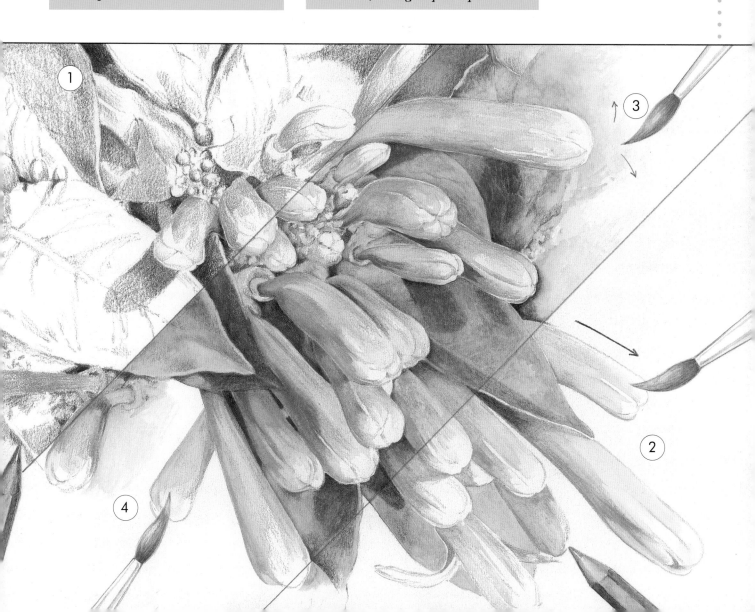

Creating texture

The surface upon which you work will have a natural effect on the texture of the artwork, but there are various techniques for creating intentional textural effects ranging from soft highlights on petals to loose foliage and stonework. The techniques on these pages will work for all watersoluble pencils. The intensity of hue and tone is a personal choice, depending upon your subject and the effects you wish to achieve.

Preparing the surface

Blotting off, lifting off and dropping in are all techniques for creating textured effects ranging from soft highlights on petals to stonework. All rely on the wash still being wet, but the effects achieved will vary depending upon how wet the wash is when you use the technique. It is a good idea to test your mix on the surface you intend to use and observe the reaction of the wash on both dry and wet areas before you start.

The wash should be shaped with consideration for the overall composition. In the example to the right, the wash – intended to be the base of a container – has been shaped to allow space for stones in front to be added later.

Preparing the surface

Lay a dark-toned wash over the whole area to be textured, using swift sweeping strokes to avoid the wash drying before it can be blotted off.

Blotting off and lifting off

Blotting off creates an uneven textured effect upon which to work. Crumpled-up kitchen paper is touched to the wet wash to lift some of the pigment away. The paint still needs to be fluid in order to be lifted effectively when blotted.

When I lift off, I use a brush dipped in clean water and squeezed dry, applying it directionally to the area of still-damp wash where a highlight is required. The way I differentiate between blotting off and lifting off is that blotting off achieves random, unanticipated textural effects into which I can work. Lifting off allows more control throughout the whole process than blotting off. In both cases, keep your initial wash as fluid as possible to prevent quick drying as this will influence the effects. To enhance the final effect, you can allow the paint to dry thoroughly and then paint over and into the effect.

Blotting off

The wet surface here has been gently blotted with a crumpled sheet of kitchen paper in different areas to create a textured effect.

A cotton bud/swab may also be used to lift pigment for a different textural effect.

Dropping in

I use the dropping in technique when I want a light form to stand forward against a dark background or, as shown on these pages, lighter areas of texture to show up against darker recesses in the stonework.

For the former approach, the light forms need to be dry, and the surrounding areas damp as the result of a coloured wash. I then use a brush to drop in a richer hue and tone up against the edge of the light form. This provides a strong contrast of light against dark and the background colour blends away into damp areas and diffuses into background shapes.

Used in the context of texture on stonework, darker hue and tone is dropped into the damp areas while those that are dry, as a result of blotting off, remain as light texture effects.

Dropping in

Before the wash has dried completely, the initial rich neutral pigment is dropped in selectively to damp areas between those blotted off.

The same mix is used to paint shadow shapes on the rocks in front. The highlighted sides are left as white paper.

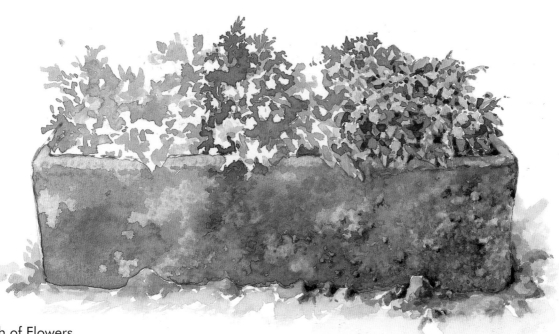

Trough of Flowers

Simple blotted shapes above a container created with the techniques shown on these pages form the basis of the flower textures. Venetian red and sap green were added in small areas using the dropping in technique. I then continued to build intensity of hue and tone to enhance the shadow areas.

Mixing the media

Derwent's ranges of pencils, sticks and blocks may be mixed in many ways. The study here demonstrates a few of these options, with accompanying notes explaining how and where the different types of pencils were used, and for what purpose.

Pencil ranges used for this study

I used **inktense pencils** for the initial underdrawing because they are permanent after being washed with water and allowed to dry – a process I call fixing. This quality meant that both dry and watersoluble media could be used to overlay without disturbing the fixed underdrawing.

I chose **drawing pencils** for this demonstration of the use of a dry medium over the initial drawing, because of their colour range.

Their subtle hues lend themselves to creating a sense of distance. Working on a cold-pressed paper surface, they also provided a certain amount of texture that adds interest to the finished piece.

Pastel pencils were used in this section of the demonstration because I wanted to show how they could suggest detail when used dry – for stonework and border flowers, for example – yet give a bolder feel if wetted, as in the lower central area of the image. The looser approach here provided textured shapes of rocks that were developed with overdrawing to enhance the contrasts.

The water brush drawing in the rocks on the lower right-hand side has been enhanced with the application of **aquatone** hues from the paint sticks (see page 22). I have used the white stick to create opaque intensity in many of the mixes.

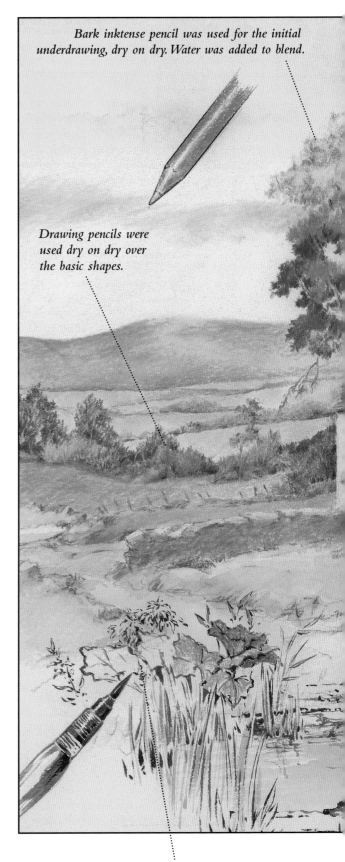

Bark inktense pencil was used for the initial underdrawing, dry on dry. Water was added to blend.

Drawing pencils were used dry on dry over the basic shapes.

Bark inktense pencil was diluted and used in a water brush for drawing.

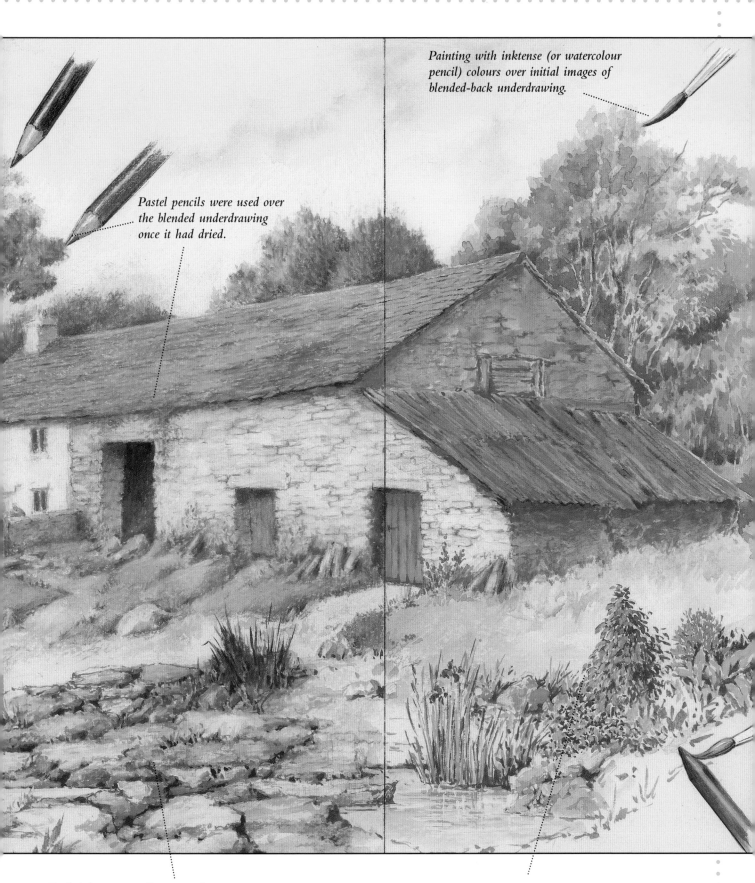

Pastel pencils were used over the blended underdrawing once it had dried.

Painting with inktense (or watercolour pencil) colours over initial images of blended-back underdrawing.

Bark inktense pencil was used over the pastel pencil work.

Painting with aquatone paint sticks over underdrawing and wash.

51

Drawing over watercolour

A loosely painted watercolour may be tightened with the addition of more detail by drawing over and into it. The range of pencils you use will depend upon the paper you are using and the effects you wish to achieve.

In this example I have demonstrated how the drawing pencils range can be used over a watercolour painting executed upon hot-pressed paper to create subtle textural effects.

Strong, bold graphite drawing can be worked over watercolour brushwork.

Painting over a drawing can be reinforced and enhanced by drawing over the brushwork with a soft graphite pencil, or with dry pencils from your chosen range.

This detail of the finished painting shows how vertical strokes have been applied along the hinges and gentle grazing over the entire door. Selective firm pressure blending enhances stonework.

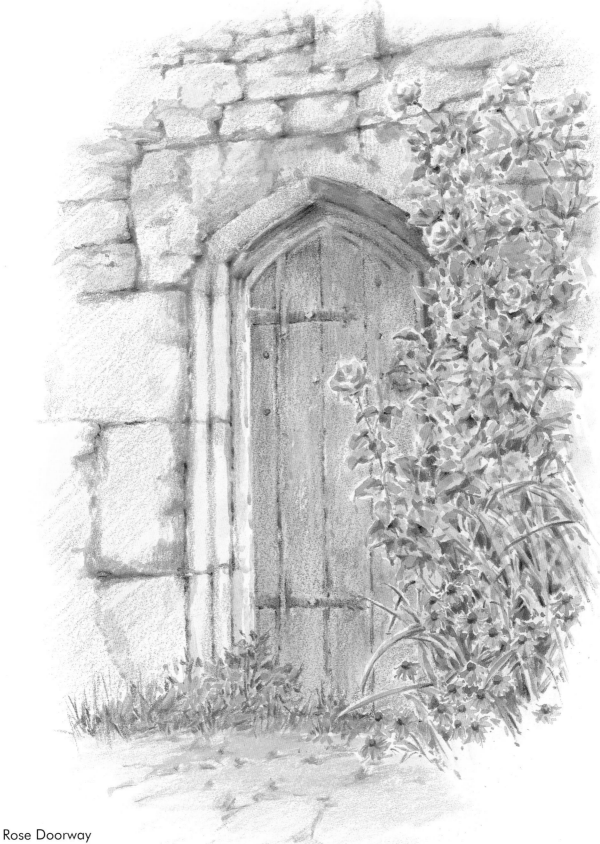

Rose Doorway

Colour adds striking contrast to the neutral hues in this painting. Pencils from the drawing range have been overlaid upon this watercolour painting to add subtle texture to the door and stonework as well as increasing the dark shadow shapes amongst flowers and foliage.

Where to start

I begin my flower drawings and paintings with an initial sketch, then use it as a reference as I build up my finished piece using the techniques and materials described earlier. These pages show my process as I work carefully from an inspirational photograph towards a finished artwork.

Making an initial sketch

Using a ballpoint pen or pencil, sketch out the image on the reference photograph on to some spare paper. Instead of being conscious of positive shapes that you see, concentrate on drawing the abstract spaces between them – these are negative shapes. With these placed accurately you will find the positives will take care of themselves.

The main objective of this investigative sketch is to place the abstract negatives shapes. Drawing straight vertical and horizontal guidelines that link the main shapes can be very helpful for accuracy. I think of the verticals as 'drop lines' and you can see how they relate certain areas to each other in my sketch.

You can use artistic licence to adapt the image in the photograph to bring a different emphasis to your artwork. Feel free to make more than one preparatory sketch to find the right composition.

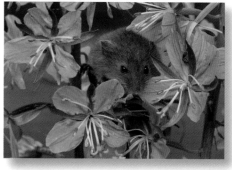

A photograph like this, taken outdoors in natural light, where the photographer has focused upon the animal's eye, allows us to see the arrangement of blooms surrounding the mouse in relation to an interesting variety of negative shapes.

Initial sketch

This sketch was produced in black ballpoint pen. The negative shapes are highlighted in green and have reinforced edges for emphasis.

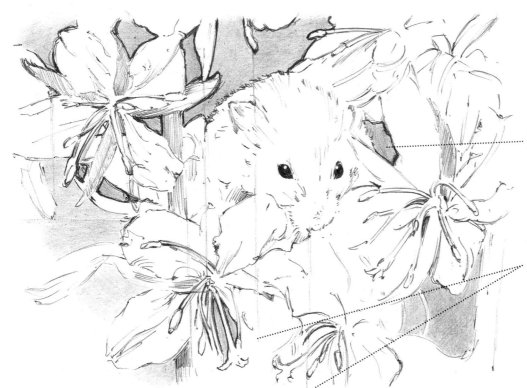

This negative shape places at least three petals and the side of the mouse correctly in relation to each other.

Drawing guidelines to relate one area to another will help you to place the components accurately.

Drawing and painting

The next stage is to transfer your sketch to working paper. For this example, I placed lightweight paper over my sketch and used a lightbox to trace the sketch through (a window also works well). This allowed me to place the components on the final paper prior to developing the various stages of the painting. I have explained these stages in the example below, which was worked in watercolour pencils upon Bockingford paper.

First stage (1)

Use the basic pencil strokes (see page 36) to draw in shapes that will remain as white paper using graphite pencil.

Second stage (2)

The edges of the petals are drawn in position with the appropriate range of colour pencil – in this case magenta watercolour pencil.

Third stage (3)

The first basic shapes are created by using washes and brush techniques (see pages 38–39).

Fourth stage (4)

The darks are gradually enhanced with brush techniques such as overlaying (see page 39) and glazing (see pages 46–47) to create strong contrasts that bring light forms forward.

Fifth stage (5)

The detail is painted in this final stage with brush strokes that follow the form of the subjects.

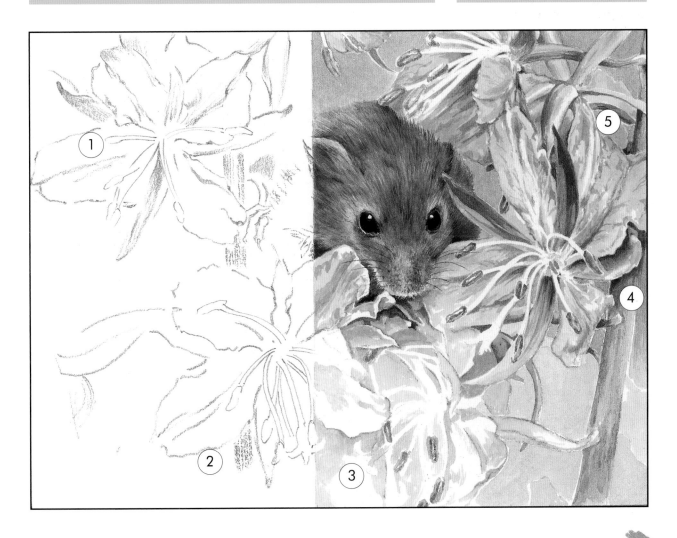

Choosing a format

An important consideration for our pictures is how we present them. We have a variety of formats to choose from and need to consider which best suits our subjects and the way they are presented.

We can choose to edit in, edit out and alter the content of the composition at a later stage, if necessary, which is part of why making initial sketches (as described on page 54) is so useful.

Landscape

Being wider than it is tall, this format is an ideal choice when showing the expanse of a garden, sweeping landscapes with hedgerow flowers or an arrangement of containers.

Portrait

Taller than it is long, this format is excellent for showing trailing or climbing plants such as this clematis. I also found this format ideal for my painting on page 7, looking through the doorway of a greenhouse.

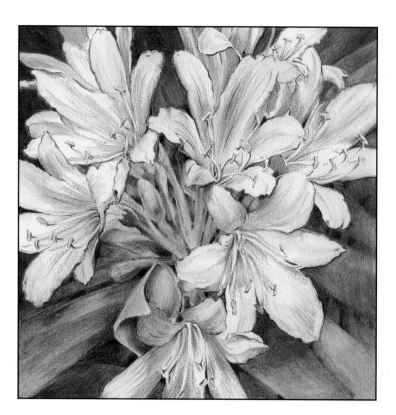

Square

This image of lilium regale *shows how effective a square image is in creating a sense of balance and drawing your eye to a close-up image.*

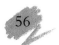

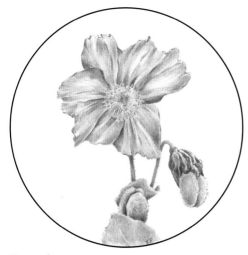

Round

Containing an image within a round format suggests to me a close focusing upon the subject. The image on page 125 demonstrates how a circular plate shape encourages us to focus upon the arrangement of blooms and leaves. When we wish to focus upon one flower in particular, like this blue poppy, no background is necessary. This enables the viewer's eye to concentrate upon delicacy and detail contained within the subject.

Oval

An oval format can be useful when we wish to omit certain peripheral shapes in order to present the main area of interest within an overall landscape or portrait presentation. In the study above, I was influenced by the actual shape of the container when looking down upon it and chose my oval to portray it and the contents.

Vignette

When we choose to present our subject without the confines of a format, we can do so in the form of a vignette. This allows the background to fade away from the main subject (evenly or unevenly) in order to encourage the observer's eye towards the centre of interest.

Flowers in containers

Containers, and the flowers that may be grown within them, are very popular. The wide choice of flowers available is surpassed by an unlimited choice of containers for them. I have had room for only a few suggestions in this section of the book, ranging from chrysanthemums next to an old stand pump to a delicate cascade of flowers in a hanging basket.

The pencils chosen for this section include both watersoluble and non-watersoluble ranges. My main aim is to demonstrate detailed interpretations and explain some of the techniques used in the depiction of flowers in containers.

I have been careful in my choice of pencils for each subject as a continuation of the explanatory texts at the beginning of the book. For example, the amount of detail I wished to include in my depiction of a bicycle with its baskets of delicate blooms and surrounding pot plants could be best achieved by using the studio range of pencils, while the subtle hues of graphitint pencils enabled me to enhance a background of stonework against a trough of chrysanthemums.

This sections ends with a step-by-step demonstration for you to follow that shows how drawings in colour pencils can be influenced by the paper upon which they are executed.

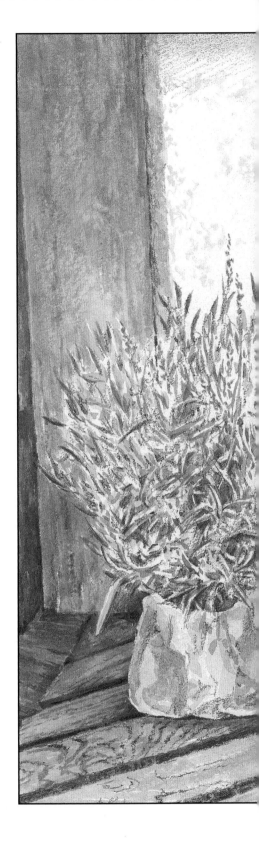

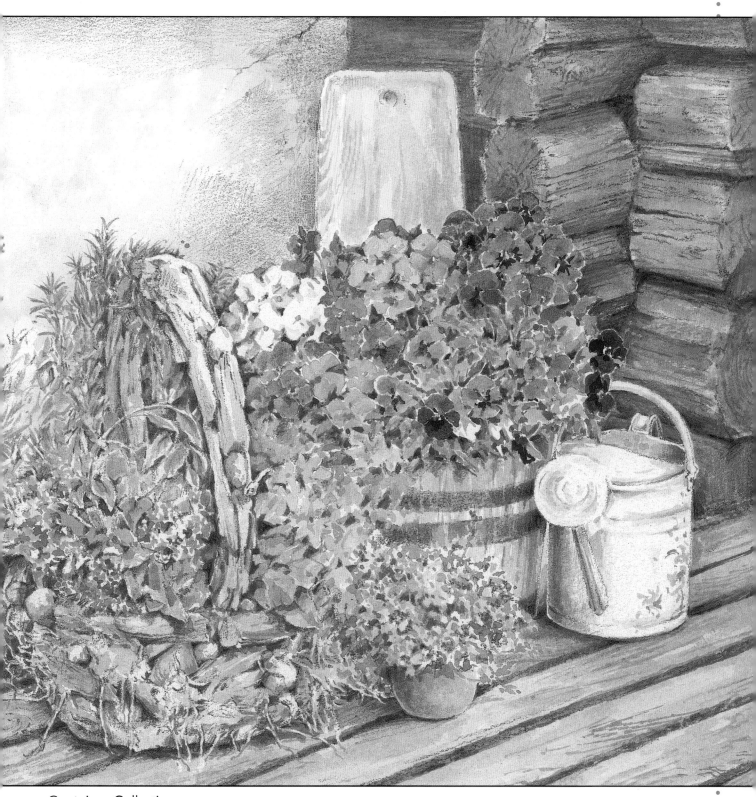

Container Collection

Whether depicted individually, or as a collection, containers offer us wonderful opportunities for drawing and painting textured surfaces. When presented against a background of even more varied textures we can use our skills of interpretation to the full. Wood, metal, plastic, basketwork, paper and stonework can all contribute towards exciting textures in neutral hues that will enhance our flower studies. This picture used inktense pencil for glazes, the underdrawing and final enhancement, and graphitint pencil and watercolour pencils for the washes and tints.

Foliage Study

When you feel you need help with your drawings and paintings, it is a good idea to remember that we are only making marks upon paper. By analysing the linear marks and tonal shapes of which our artworks are composed, a deeper understanding of the techniques used will develop, and even complex pictures can then be logically broken down into achievable stages.

Foliage is a vital supporting part of any flower painting or drawing and the study opposite, of a display of different leaf shapes, is an example of how a variety of elements can work together to give an overall impression. Amongst the elements we can identify positive shapes such as the leaves and stems, and the negative shapes between the positive shapes, like the recesses between leaves.

A variety of techniques has been used in order to create these elements. Some are simple and flat-toned, while overlaying and blending (see pages 39 and 44–45) on others give the elements dimension and depth. Pencil is applied in flat blocks for leaf surfaces and in zigzags for small negative shapes and the tonal shapes in the shadow recesses. Clean lines made with varied pressure and those drawn more unevenly and erratically help to create complexity and interest in the artwork.

Tone is worked up to many of the elements to give them a crisp edge, before the pencil is worked away so the colour blends out into a lighter tone. This 'up-to-and-away' application complements the counterchange technique, where light forms are placed against dark shadow shapes, followed by dark shapes against light backgrounds.

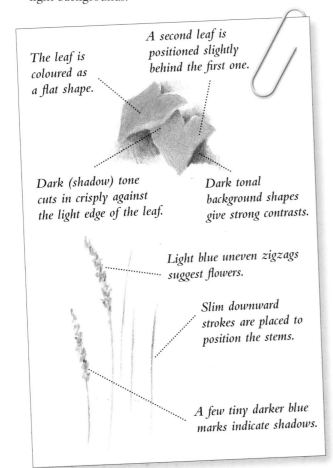

The leaf is coloured as a flat shape.

A second leaf is positioned slightly behind the first one.

Dark (shadow) tone cuts in crisply against the light edge of the leaf.

Dark tonal background shapes give strong contrasts.

Light blue uneven zigzags suggest flowers.

Slim downward strokes are placed to position the stems.

A few tiny darker blue marks indicate shadows.

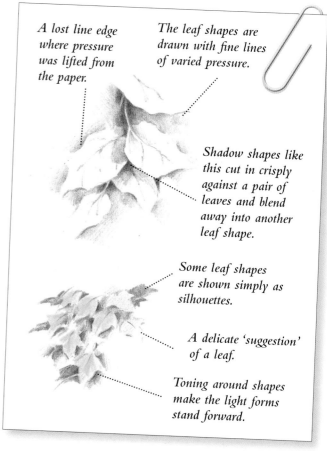

A lost line edge where pressure was lifted from the paper.

The leaf shapes are drawn with fine lines of varied pressure.

Shadow shapes like this cut in crisply against a pair of leaves and blend away into another leaf shape.

Some leaf shapes are shown simply as silhouettes.

A delicate 'suggestion' of a leaf.

Toning around shapes make the light forms stand forward.

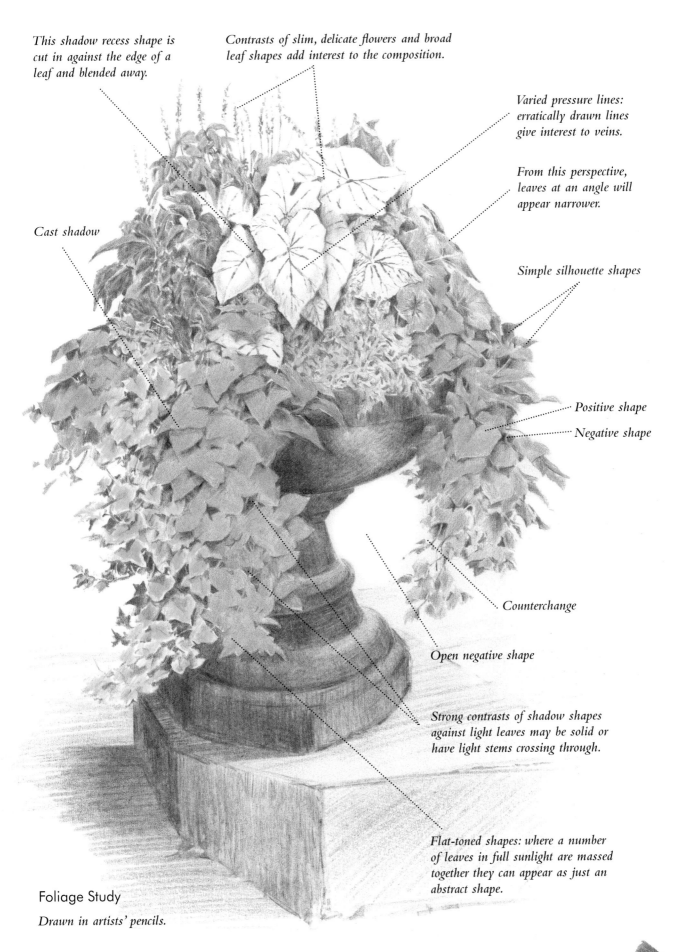

This shadow recess shape is cut in against the edge of a leaf and blended away.

Contrasts of slim, delicate flowers and broad leaf shapes add interest to the composition.

Varied pressure lines: erratically drawn lines give interest to veins.

From this perspective, leaves at an angle will appear narrower.

Cast shadow

Simple silhouette shapes

Positive shape

Negative shape

Counterchange

Open negative shape

Strong contrasts of shadow shapes against light leaves may be solid or have light stems crossing through.

Flat-toned shapes: where a number of leaves in full sunlight are massed together they can appear as just an abstract shape.

Foliage Study

Drawn in artists' pencils.

61

Bicycle Surrounded by Flowers

Contrasting foliage masses and crisp flower petal shapes with the forms of man-made containers can provide a wealth of visual interest – particularly if the containers are as interesting and varied as those attached to this intricate bicycle. With its pannier and basket both filled with trailing blooms, it is an interesting challenge. The finished picture is on pages 66–67, and the stages I used to reach this are detailed on the following pages.

While organic forms like flowers can be represented well fairly randomly, familiar man-made objects like this bicycle need to be accurately represented. Quick pencil sketches will help you understand your subject and will help you place the surrounding components correctly, particularly if you look for the negative shapes (see opposite).

Initial sketch

You can see, from the placing of a red line in the form of a zigzag, how the viewer's eye may be encouraged to move from the container in front of the wheel on the left, up the pedal and supporting bar of the bike to travel along the crossbar. In this way the plants in one container relate to those in another and hold the composition together. Sketching will help you identify the best way to represent your image.

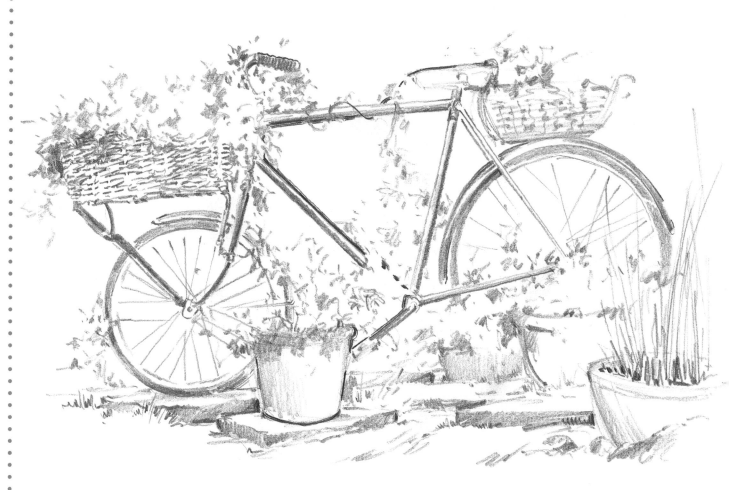

Developing your initial sketch

In addition to encouraging the viewer to appreciate the composition of our artworks by 'leading the eye' we can also enhance their experience by providing an interesting arrangement and variety of negative shapes. You can also add flower arrangements from other reference material if they are not actually on the bicycle. The refined sketch below brings more emphasis to the flowers themselves, and uses a different bicycle with softer lines that echo the cascading flowers.

Think of the negative shapes in the study below as the shapes that you could put your hands or fingers through and feel around within the structure of the bicycle. This will help you appreciate that, by drawing the areas you can touch around that space – and concentrating upon the shape of that space itself – you will have placed the surrounding positive form components correctly in relation to each other.

You will see in the sketch below how I have placed flowers and foliage shapes in such a way that I have some control as to how they influence the overall study when relating to the basic structure of the bike.

Developing your sketch

Here, the red lines show a variety of the interesting negative shapes that are so important for good composition.

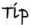

Tip

An understanding of negative shapes and how to use them to help place the positive forms is explained on pages 54 and 55.

From sketch to painting

When drawing the structure for your final piece, you may find a few light guidelines from the sketch will help you to relate components to each other. This way of working is demonstrated to the right, where I have shown the underdrawing only on the rear wheel.

You can use a sharp pencil for graphite drawing and layer colour over this, or draw directly in colour, as below. Studio coloured pencils are ideal for intricate studies like this bicycle with its basket of delicate flowers.

'V' shapes

Where two areas meet at an acute angle on your drawing, a 'V' shape is formed. This bicycle study has many, notably where the spokes join the wheels. These 'V' shapes provide excellent starting points for all sorts of subjects.

Draw one side of the spoke using a very sharp HB graphite pencil, then work up to a slim strip of untouched paper on the other side, using the background colours.

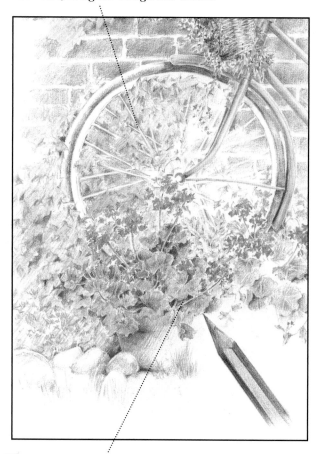

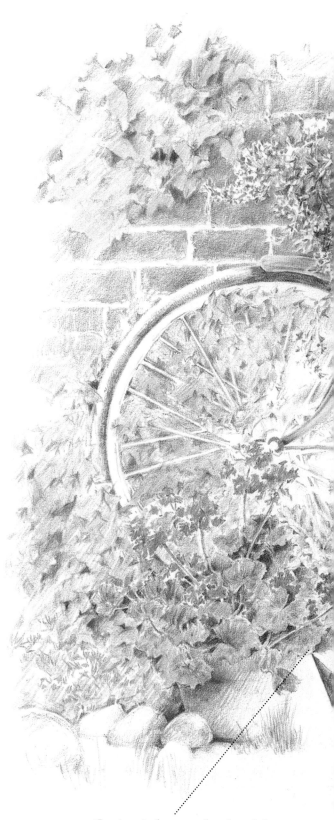

Work up to each side of the light stems in the same way as for the spokes.

Cut in crisply up to the edge of the leaf and work away from it.

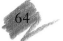

Position the bricks in the wall with pale hues before developing them.

Small negative shapes like these will place the surrounding leaves in a natural environment.

This horizontal guideline will position two areas correctly in relation to each other.

Look for little shadow shapes like this to develop a three-dimensional impression.

Looking at the negative shape between the wheel and external guideline will help you draw the wheel correctly.

Completing the work

Faced with a rather bland wall behind the bicycle I felt a vignette presentation would suit this composition and my choice of pencils and paper. This combination is ideally suited to detail representations. Including steps as well as container plants in the foreground adds interest and encourages the eye to move within the unusual vignetted portrait format.

The main area under observation should be the front of the bike, so more detail is used here. The rear of the machine and the surrounding area are drawn using the lost and found approach (where the line is broken, and picked up further along), with less clarity, and although initially drawn in detail with the use of guidelines, the rear wheel – with entwined foliage – is only suggested. This prevents the eye from being too confused with detail.

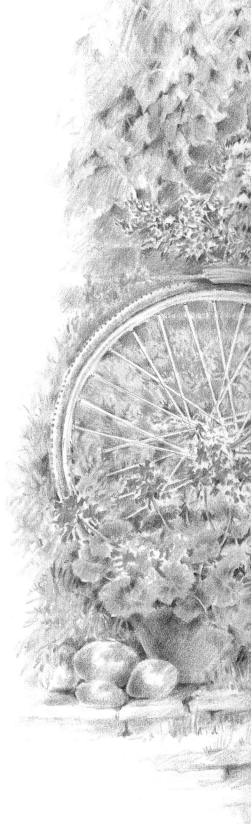

Bicycle Surrounded by Flowers

A vignette format provides the restful atmosphere that contrasts soft organic shapes with the strong, eye-catching form of a bicycle.

Studio pencils were used in order to achieve a crisp, tightly controlled drawing of the man-made subject, yet they were also ideal for delicate, detailed representation of supporting flowers and foliage.

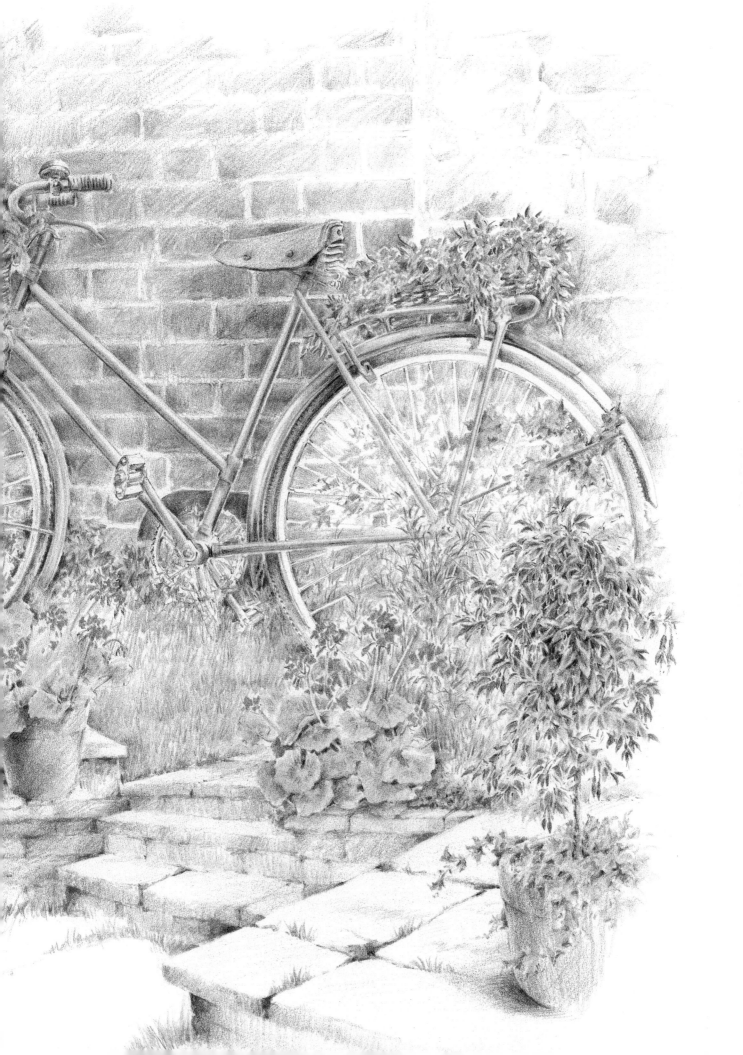

Pump with Chrysanthemums

The trough of an old pump is often used as a container for plants, and this study of the pump, with its pipe outlets facing in different directions, has numerous changes in hue and tone. These pages show the techniques and colours used to demonstrate how correctly placed shadows and highlights can help us achieve a three-dimensional impression. The finished artwork can be seen on page 71.

Our drawings and paintings have more drama and interest if we use a variety of tones – from the lightest light (which is often white paper) to the darkest dark. Tone refers to the relative lightness or darkness of a colour, while hue refers to the specific colour (e.g. sky blue).

You will see in the finished artwork that the darkest darks are the smallest areas. They do, however, give maximum contrast when used directly against light forms – for example on the topmost pipe of the pump. You can see how the dark interior contrasts strongly against a light rim. This, and the dark cast shadow beneath, gives the impression that the pipe is turned towards us.

Tonal contrasts can also help us describe textural effects, depending upon how they are used. As an example, on the detail to the right, compare the texture suggested at the top of the pump with that shown on the wall behind, through the way in which the pencil has been applied.

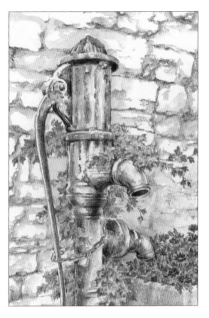

Detail of the finished artwork, showing the pipe outlets of the pump against the wall.

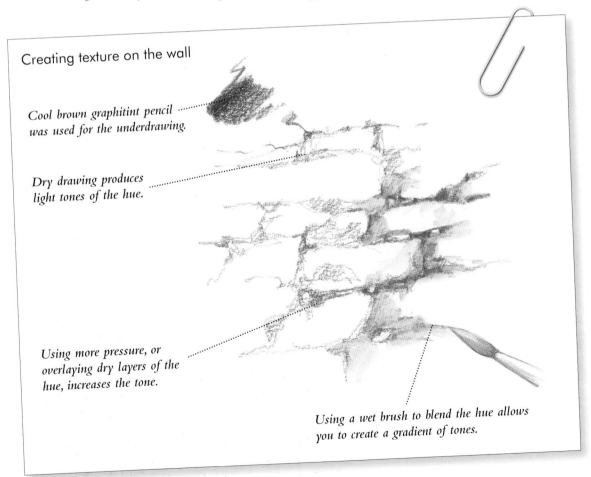

Creating texture on the wall

Cool brown graphitint pencil was used for the underdrawing.

Dry drawing produces light tones of the hue.

Using more pressure, or overlaying dry layers of the hue, increases the tone.

Using a wet brush to blend the hue allows you to create a gradient of tones.

Contrast for impact

Contrasts – of shape, texture and tone – are important considerations and, combined with the direction in which we apply our strokes, enable us to produce three-dimensional impressions. On these pages I demonstrate how the techniques were used and combined to produce the finished painting.

The direction in which we place our strokes in order to depict different subjects is important. On the diagram below, I have used small arrows to show the curved direction of the pump. The leaves, although wider forms, were also placed using similar stroke directions. When massed, as shown in my final picture overleaf, they give an overall effect of numerous flowers growing in a container.

Stroke direction for the flowers

For the examples here, I have chosen graphitint watersoluble pencils. The soft, subtle hues are ideal for the pump and wall (below), with contrasting vibrancy of colour when water is added to leaves and flowers (right).

Curved, upwards movements were used for chrysanthemum petals, using the colour chestnut.

Leaves were added in the same way, by applying green grey pencil with curved upward movements.

Dry on dry application. The arrows indicate the direction of the stroke.

Adding water with a small brush brings out the colour.

Stroke direction for the pump

Well placed directional strokes will help you develop strong contrasts for an effective and convincing three-dimensional impression.

This ballpoint pen and wash diagram will give you an idea of how you can think about the direction in which you can apply your strokes.

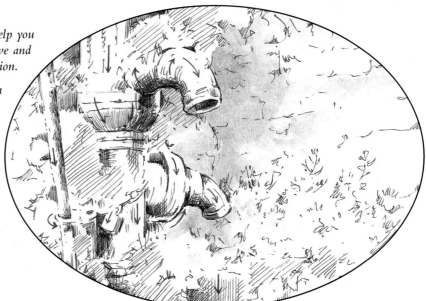

Graphitint pencils colour key

Stone wall: cool brown

Climbing foliage: ivy

Chrysanthemum flowers: chestnut

Pump: shadow

Chrysanthemum foliage: green grey

Supporting foliage: meadow

Developing the artwork

The area shown outside the oval is at an early stage, drawn dry on dry, while the area within it is completed with drawn lines of water gently applied to blend the pigment. This helps to demonstrate how overlaying (see page 39) increases hue and tone.

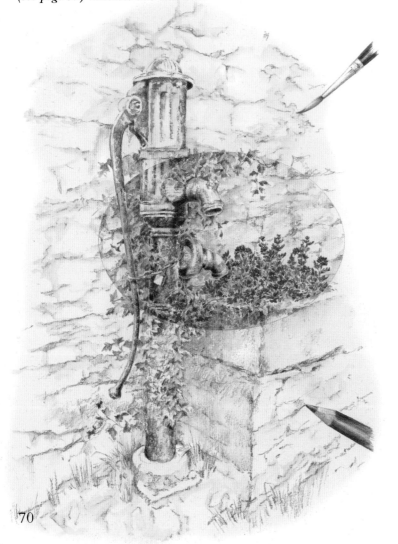

Opposite:
Pump with Chrysanthemums

I chose graphitint pencils and a cold-pressed Not surface paper for this study as it works well with graphitint techniques. Owing to the qualities of the paper, colour can be lifted from areas of the wall with a damp brush where highlight effects are needed. This gives you another way of increasing the tonal range. Slim areas of white paper were retained, as light-toned areas next to darker tones help to bring the form of the pump forward.

In terms of hue, the colour shadow was used to draw the shape of the pump lightly in place and cool brown lightly positioned the stonework of the wall. Sage was washed gently over some areas of the wall.

The addition of richer hues in the form of the red chrysanthemum flowers (using chestnut pencil) adds greater interest and contrast in colour, as well as tone. Flowers can make a huge difference to your artwork, even when they are only a small area of the composition.

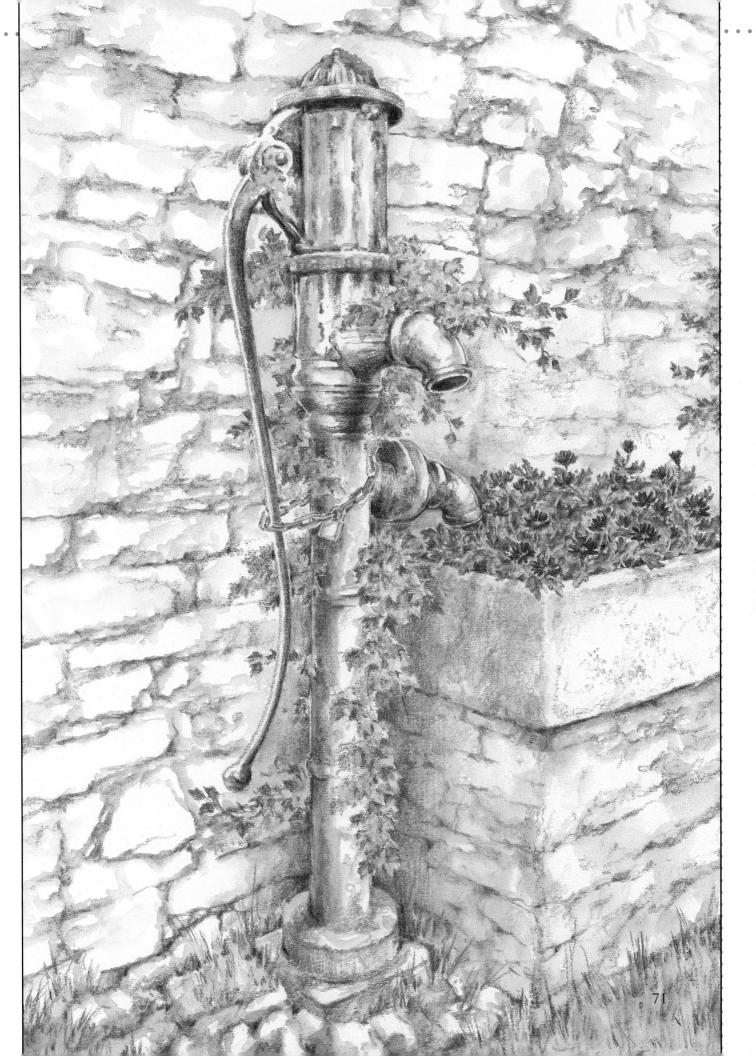

Flower-filled Boots

The examples on the following pages both show the same stretch of wall supporting an old pair of boots at one end and a box of mixed flowers at the other. This provided me with plenty to work from, and I experimented with different formats to see which worked best.

I first tried an oval format (shown opposite) and started to include much of the background content. As I worked, I decided that there was too much going on and that I would edit out, rearrange and change the content in order to present a simplified version within a circular format, shown overleaf.

The notes on this page show the valuable lessons learned on this abandoned format that informed the final piece.

Use academy watercolour pencils for this piece.

Gently graze the colours over drawn shapes. When a wet brush touches these areas, they dissolve into the first underlay.

This shape sits between two objects. Use firm pressure upon a light green pencil to burnish it and unify the three parts into a whole.

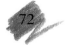

72

*Blend dry colours together using
clean water on your brush.*

*Work the initial
drawing dry on dry.*

*Draw the image in detail as a line
drawing before overlaying colour gently,
working dry on dry.*

73

Choosing a final format

Trying out an oval format helped me to decide upon a circular format to simplify the composition in order to place the focus on the main subject of the boots as containers for the flowers. In the original oval format, seen on pages 72–73, I felt there was too much activity on the left-hand side and too little on the right, which detracted from the main areas of interest. You will see that I also enhanced negative shapes, creating important contrasts, in the final composition shown opposite.

These particular flowers are a pink variety of chrysanthemum. If you compare them with the more distant chrysanthemums on page 69, you will see that the techniques to produce both are similar, as demonstrated below. These larger, closer flowers require a little more detail, as shown.

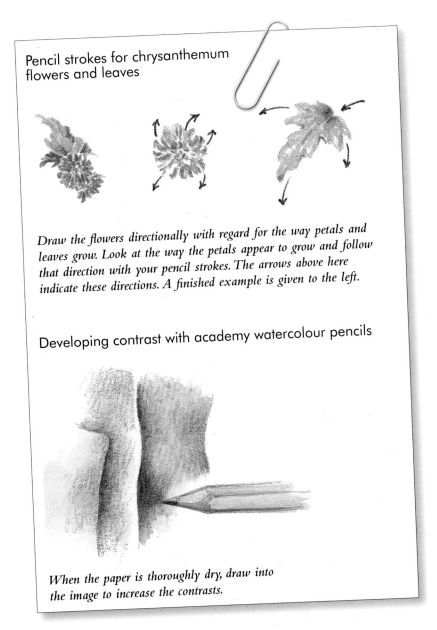

Pencil strokes for chrysanthemum flowers and leaves

Draw the flowers directionally with regard for the way petals and leaves grow. Look at the way the petals appear to grow and follow that direction with your pencil strokes. The arrows above here indicate these directions. A finished example is given to the left.

Developing contrast with academy watercolour pencils

When the paper is thoroughly dry, draw into the image to increase the contrasts.

Flower-filled Boots

This piece was worked in academy watercolour pencils on cold-pressed Not surface paper.

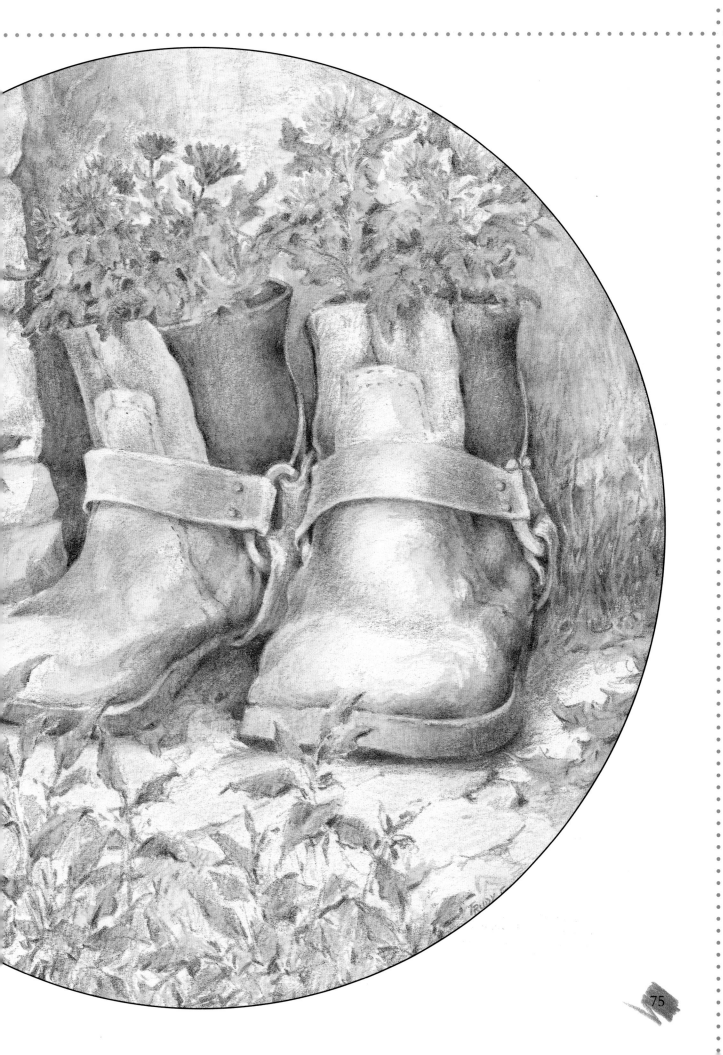

A Mass of Flowers

The following sketches and the finished picture on pages 78–79 use the same source as the *Flower-filled Boots* on the previous pages. Further along the same wall was a plain box containing masses of flowers. From the more complex boots with limited flowers I was now considering the simplicity of a box with a more complex arrangement of blooms and foliage. The shape of the box suggested a different format and I felt it would be a good idea to concentrate upon the flowers and foliage for colour, and to retain the underdrawing of a limited monochrome background.

I started by creating a loose sketch to get a feel for the subject and create an impression. Tonal areas were enhanced, while positive forms were left as light shapes as in the initial sketch below.

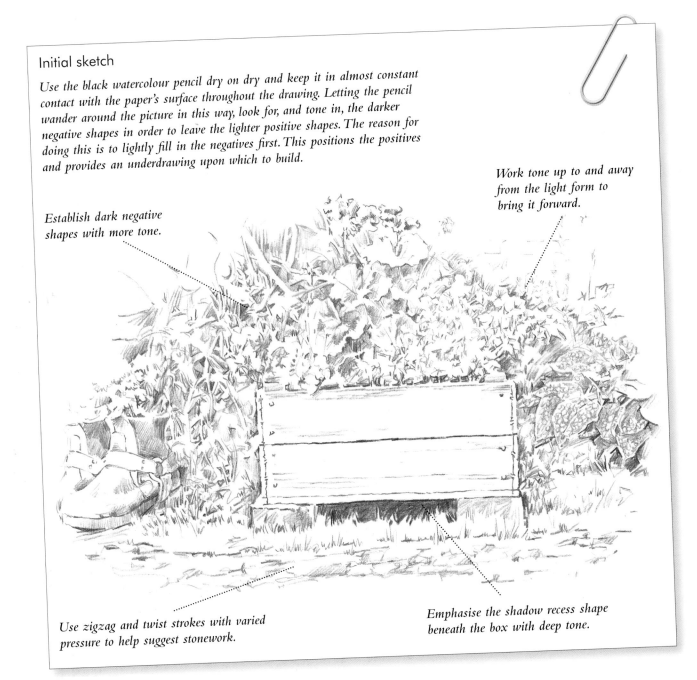

Initial sketch

Use the black watercolour pencil dry on dry and keep it in almost constant contact with the paper's surface throughout the drawing. Letting the pencil wander around the picture in this way, look for, and tone in, the darker negative shapes in order to leave the lighter positive shapes. The reason for doing this is to lightly fill in the negatives first. This positions the positives and provides an underdrawing upon which to build.

Work tone up to and away from the light form to bring it forward.

Establish dark negative shapes with more tone.

Use zigzag and twist strokes with varied pressure to help suggest stonework.

Emphasise the shadow recess shape beneath the box with deep tone.

From sketch to painting

Transfer the sketch to your final paper and begin to work through the painting. A neutral hue is ideal for the initial underdrawing – here I have used a neutral grey academy watercolour pencil to place the basic shapes and establish the cast shadows.

Once the underpainting has been laid in and allowed to dry, wash pale green over the light (positive) shapes of the leaves and paint the flowers in pale hues, before establishing the other areas like the wooden box and grass. The colour sketch below explains the techniques used for the early stages of the most important sections of the painting.

Colour sketch

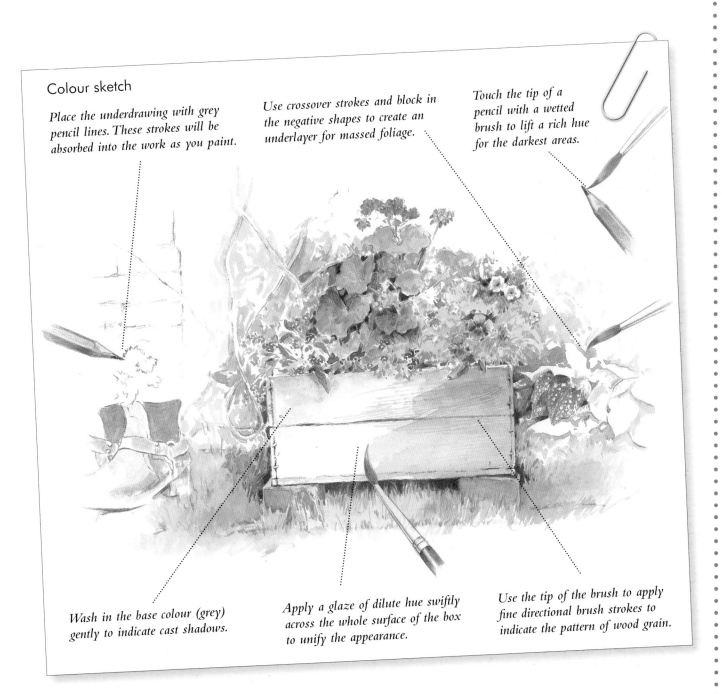

Place the underdrawing with grey pencil lines. These strokes will be absorbed into the work as you paint.

Use crossover strokes and block in the negative shapes to create an underlayer for massed foliage.

Touch the tip of a pencil with a wetted brush to lift a rich hue for the darkest areas.

Wash in the base colour (grey) gently to indicate cast shadows.

Apply a glaze of dilute hue swiftly across the whole surface of the box to unify the appearance.

Use the tip of the brush to apply fine directional brush strokes to indicate the pattern of wood grain.

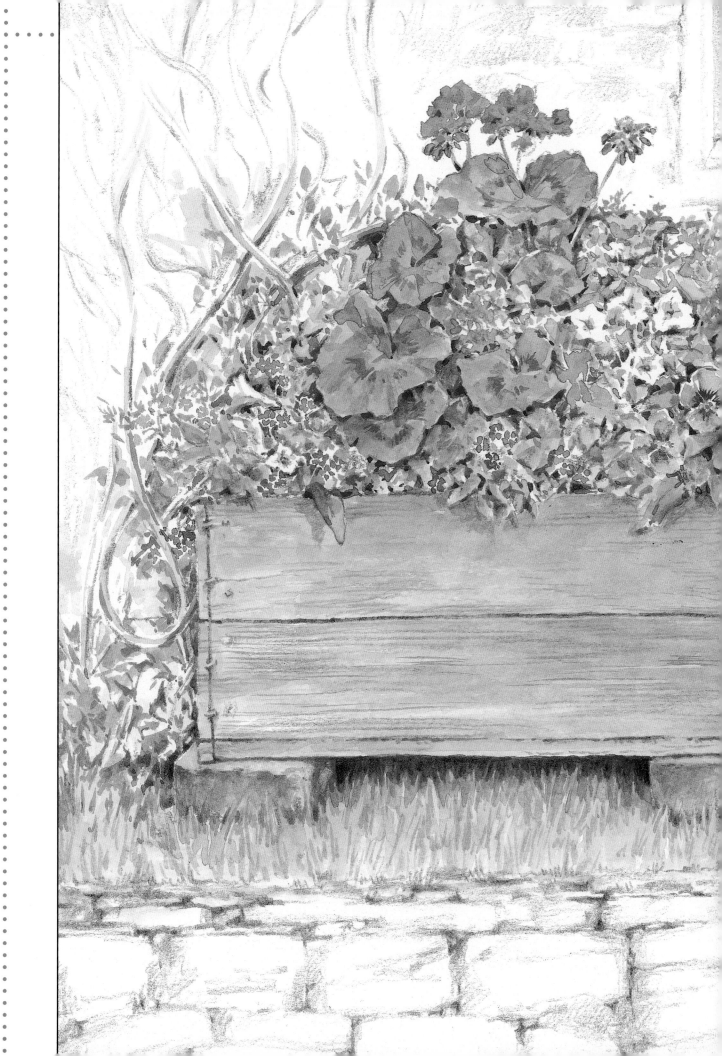

Completing the painting

The pale washes over the leaves and flowers provide focal points which can then be developed by seeing how one group or mass relates to the others. The final stages of the painting process are to glaze over the leaves and box with relevant brighter hues and to increase the intensity of the contrasting darks with careful brushwork.

In order that the painting does not become too complex and busy, keep the background mostly indistinct. Aim to retain most of the pale underdrawing in the background, but use some delicate brush strokes to take a hint of colour to the left and right of the main box. Gentle glazing using yellows in various areas of foliage, and yellow ochre with raw umber over the box, will enhance the final effect. Retain white edges around the simply represented blue flowers for a crisp impression.

This study may look complicated, but the shapes used are simple in themselves. It is the thought behind the execution that creates these effects.

A Mass of Flowers

Worked in academy watercolour pencils on cold-pressed Not surface paper, this piece balances the very complex mass of flowers and foliage with a comparatively simple box and background. The container gives the eye somewhere to rest, and adds structure to the subtle and elaborate contents.

Hanging Basket

The photograph below contains is a lot for your eye to take in, and that can make it difficult to know where to begin. I like to 'work from within', which means I let my eye travel naturally to an area where I can see strong contrasts of shape, tone or colour. Then, should I lose my place, I can easily let this process happen again.

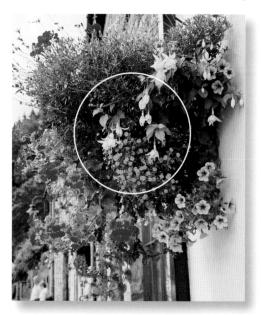

The source photograph, with the starting point circled. I did not wish to portray such strong contrasts in the finished piece, but the fact that such an eye-catching point is present in the reference is very useful.

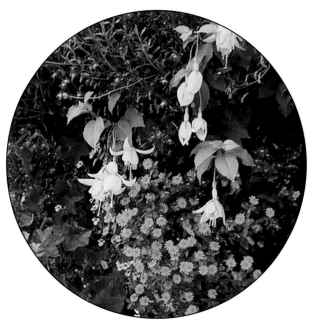

This exploded version of the circular detail shows the contrast between the light flower heads and the leaves directly above them. Once this striking area was complete, I started to work outwards from this 'anchoring' area to the edge of the image.

Strokes used in the colour sketch

When approaching any subject, I am guided by the content as to how I wish to represent it. This also influences the medium chosen. I call the method I use to describe forms 'the wandering line'. As I work, I let the tip of my pencil remain in contact with the paper's surface. I let it wander around the form of an object using only light pressure at first, and increase the pressure when I feel the positions are correct.

Imagine a tiny spider walking over the surface and let your pencil travel up, over and around the images, as well as from one form to another – relating them with a shape between. When you have drawn a small area you can work outwards to an adjacent area, extending the picture until the image is complete.

For this subject, I wanted my pencil drawing to hold everything together. Beginning with a wandering line and a variety of strokes, I created a foundation upon which to paint the vibrant colours that initially attracted me to this exciting arrangement.

Whichever range of pencils you use for your artwork, use the basic strokes shown on page 36 for the underdrawing. Breaking the image in the detail down to these elementary strokes allows you to gradually build up even a very complex finished image.

For this hanging basket, I chose the inktense range of pencils because I wanted to draw the main shapes loosely, using non-soluble outliner pencil first. This gave me permanent line and tone, over which diluted inktense hues were painted loosely to build hue and tone.

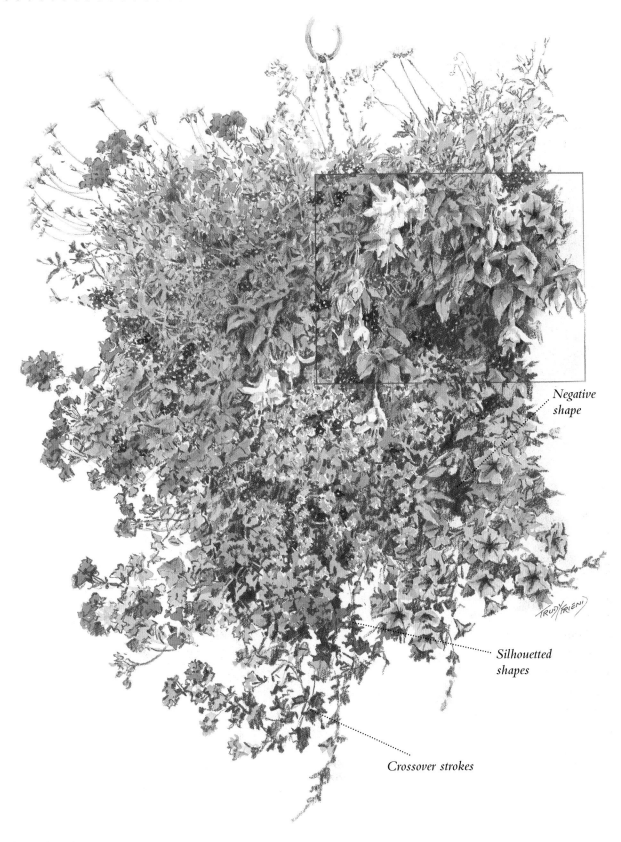

Negative shape

Silhouetted shapes

Crossover strokes

Colour sketch

This sketch identifies a few of the basic strokes I have used for the various parts of this complex hanging basket. The area in the box has been developed in more detail than the remainder to show how the hue and tone are built up once the main shapes have been established.

Completing the artwork

The completed pictures throughout the book have been presented in various formats (see pages 56–57), each chosen to best portray that particular subject. All have relied upon some background as a support for the main image.

With the subject of this hanging basket I have chosen not to include any background as there is so much content within the display. Our eye has enough to absorb without additional support, and untouched paper surrounding this profusion provides a calming contrast. Conversely, a simple composition might benefit from a more complex background.

Opposite:
Hanging Basket

Inktense pencils and cold-pressed Not surface paper work well together and the interpretation here is more detailed and delicate than the colour sketch on page 81.

A study like this will take me many hours of concentrated work so I have frequent breaks, returning to the picture with a fresh eye and renewed enthusiasm each time.

The techniques used in this painting

This expanded version of the highlighted box on page 81 gives a good indication of the level of complexity in the overall picture. You can usually judge the complexity of the format and the sort of background that will work best from the content of a small section of a drawing like this example.

You can either paint the coloured areas first and then draw into and around them, as in the blue areas, or loosely place the images and add the colour afterwards, as in the flowers.

Apply your pencil and brush strokes in different directions to create the effect of massed leaves and flowers.

Create angles by making zigzag strokes with an outliner pencil in varied directions.

Apply inktense pencil washes loosely.

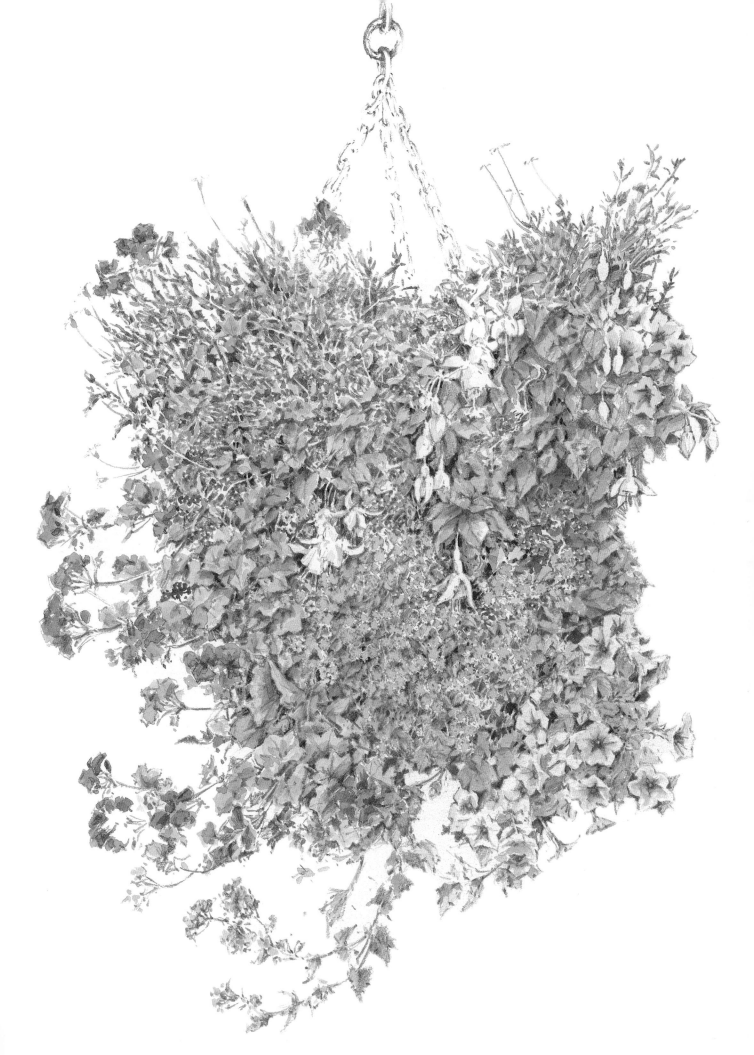

Old Boots on the Doorstep

You will need

Watercolour paper: 300gsm (140lb)
High White Saunders Waterford Not surface,
23 x 31cm (9 x 12in)
Coloursoft pencils: light green, dark green,
deep red, deep cadmium, orange, acid yellow,
loganberry, brown, brown black, brown earth,
mid grey, peach, ultramarine, iced blue
Utility knife for sharpening pencils

Old boots are popular as containers for flowers such as these pansies and geraniums. The material from which the boots are made provides interesting textures – as do the lichen and moss accumulated upon their surface.

For this study I have chosen a textured paper, combined with the softest of coloured pencils, in order to create these strong textural effects. The velvety softness of coloursoft pencils creates dense colour that is perfect for mixing and blending.

Texture can be emphasised even more by the way your strokes are placed. The first stage shows how a contoured 'tacking stitch' application can be used to suggest folds in heavy fabric. For solid areas of colour – to block in leaves and petals, for example – you will need more pressure upon the pencil.

First stage

Use the coloursoft pencils shown to practise the contoured pencil strokes and familiarise yourself with producing the correct textures on the surface of the paper.

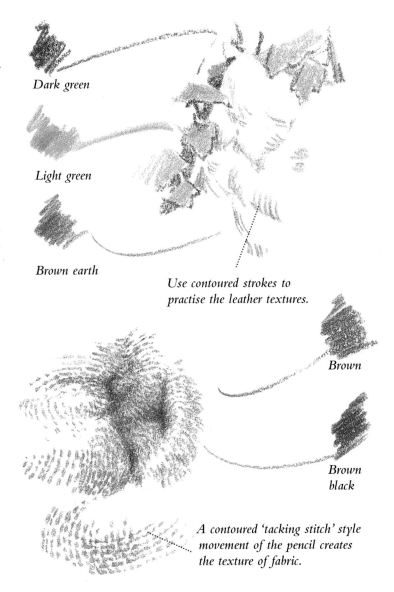

Dark green

Light green

Brown earth

Use contoured strokes to practise the leather textures.

Brown

Brown black

A contoured 'tacking stitch' style movement of the pencil creates the texture of fabric.

84

Second stage

This stage consists of lightly applying the pencil in wandering lines and blocking in with tone. Working with a brown coloursoft pencil and light pressure, let the tip 'wander' around the forms in various directions.

Once you are happy with the way the boots have been positioned, increase the pressure on the pencil to position the shadow lines and tonal shapes. Block in the latter with solid tone to show shadow recess shapes, and work up to the light edges of forms and gradate the colour outwards.

Using dark green and light green for the leaves, and deep cadmium and acid yellow for the flowers, block in the basic shapes, staying within the coloured lines.

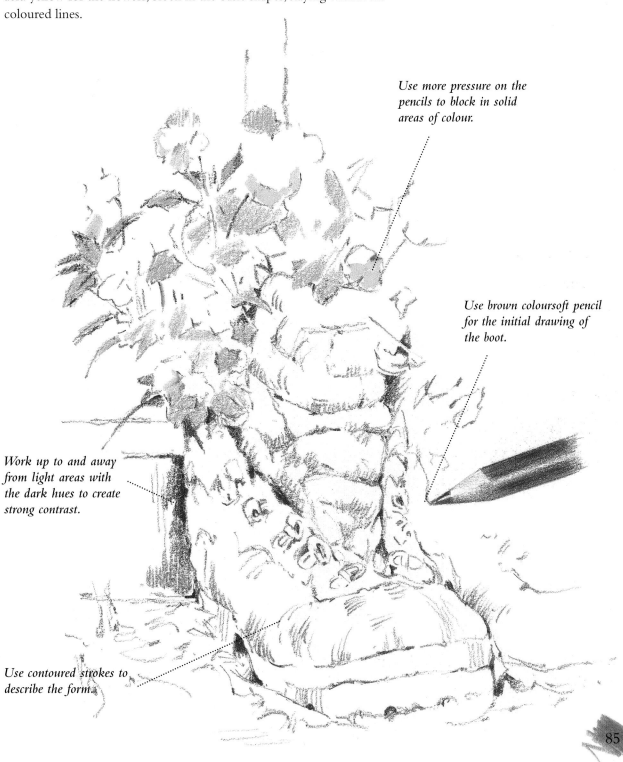

Use more pressure on the pencils to block in solid areas of colour.

Use brown coloursoft pencil for the initial drawing of the boot.

Work up to and away from light areas with the dark hues to create strong contrast.

Use contoured strokes to describe the form.

Third stage

Colour the whole study using pale hues first, as shown on the right-hand side of the illustration below. Introduce deep red, deep cadmium, orange and loganberry for the geranium and red pansy petals. Next, begin overlaying the same colours to increase intensity of tone. On the left-hand side more colour has been introduced and tonal values increased in the layering process.

Build the drawing using the coloursoft pencils to achieve a textured effect for the leather of the old boots and mid grey for the worn stone of the doorstep. This stage shows you how the rough surface of the paper helps create texture. To reduce this effect, you need only to increase pressure upon the pencil for a smoother effect to appear – for example on the flower petals.

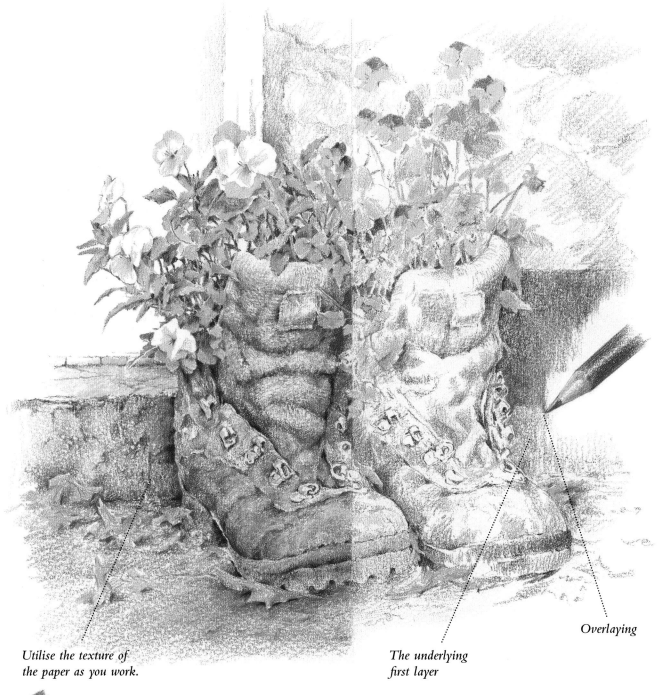

Utilise the texture of the paper as you work.

The underlying first layer

Overlaying

86

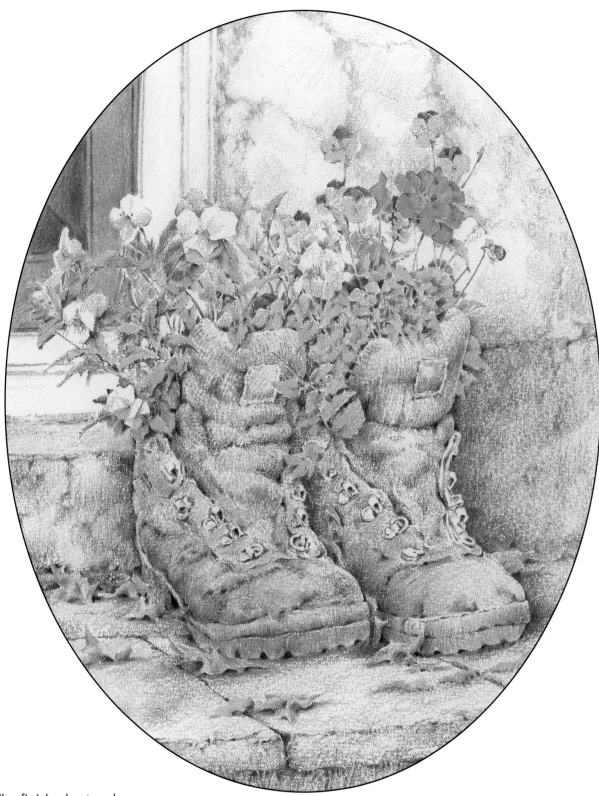

The finished artwork

The oval format means the focus is upon the main subject rather than a larger area of door, wall and step. By showing small areas of these elements, as a support for the main images, the background shapes and colours have more interest.

Pale pansies on the left are enhanced by the ultramarine and ice blue door while brighter hues of other pansy varieties and a geranium on the right contrast against paler stonework. Considerations like these are important when planning your compositions.

Flowers in the garden

Using gardens as the focus and backdrop for our flower artwork gives us the opportunity to place the flowers in interesting juxtaposition to walls, gates, paving, areas of lawn and other man-made structures. Water features are popular additions to both small and large gardens, with ponds and mini-waterfalls giving us opportunities to include movement in our depictions. These larger-scale images reward a looser way of drawing and painting flowers with coloured pencils.

In many gardens we can see a profusion of colour and that is why I have started this section with a colourful array of dahlias and accompanying seasonal plants in a large and colourful group. Portraying flowers in gardens does not, however, mean that we need to stand back from them and see them as a mass. Many flower lovers use containers within garden settings so the skills and information you learned in the last chapter can be expanded upon by following the instructions and guidance here.

This chapter also looks closely into detailed representations of both lilies and rhododendrons, as well as flowers not traditionally used for decoration, like onions. Close study of parts of the plant beyond the flower head can improve your flower drawing, and these are covered in this section of the book. The neutral hues associated with the bulbs, tubers and rhizomes of garden flowers are, I feel, as important as vibrant colours for us to practise colour mixing, whether working with watersoluble or dry media.

All of our artwork relies both upon our understanding and technical skill, and this chapter will help you relate how every part of the plant is important to drawing and painting the beauty of the flower.

Garden Visitor

This charming squirrel is perched on apple blossoms; both the squirrel and flowers were worked in pastel pencils. Animals can be wonderful complements to your flower paintings and drawings, and the garden is a natural place to find wildlife.

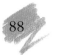

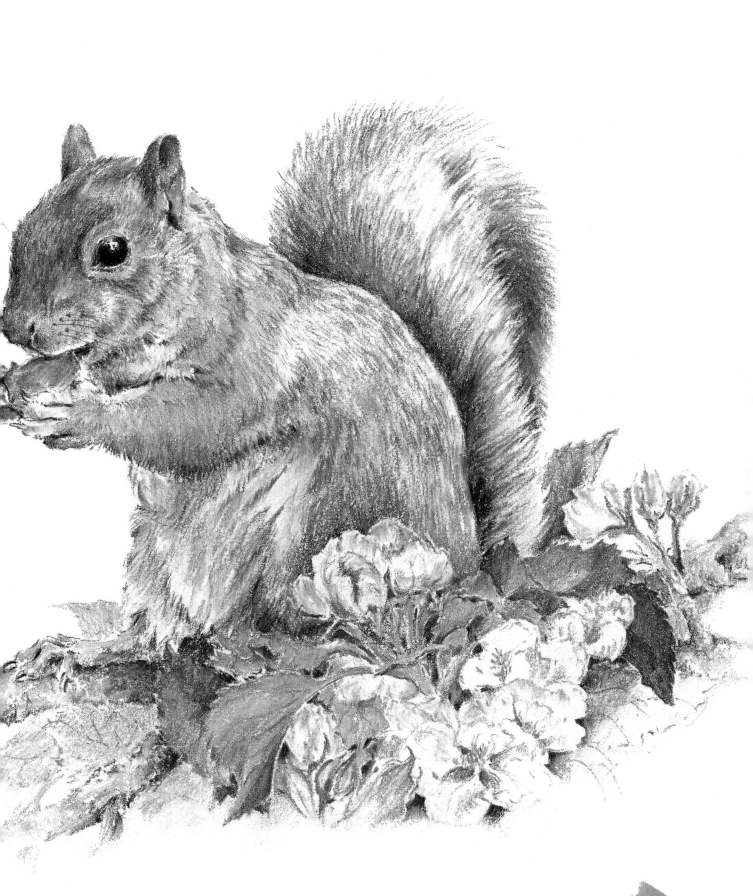

Colourful Corner

Garden subjects lend themselves particularly well to mixed media works. Derwent's pencil and stick ranges can be successfully mixed to suit your subject choice and the surface upon which you are working. For the colourful corner of a garden shown opposite, I chose to work on hot-pressed smooth high white paper and, for various reasons, used four different ranges for this study.

Shown opposite is a picture of a corner of a garden, filled with colourful flowers. It is presented within a partial format, containing one side and a base. The third edge is a vignette, and the top remains undefined.

Vegetable gardens can be as colourful and varied as flower gardens. They also provide exciting and interesting forms for the artist. For this study I have included onions in their regimented rows as a distant image to contrast with the profusion of colourful dahlias and other flower varieties in the foreground. Bright red runner bean flowers could equally well contrast with the delicate white flowers of onion globes.

The following pages explore this picture and explain the techniques I used to draw and paint it.

Opposite:
Colourful Corner

Containers packed – and ready to be wheeled away! This piece is executed in mixed media on hot-pressed high white paper.

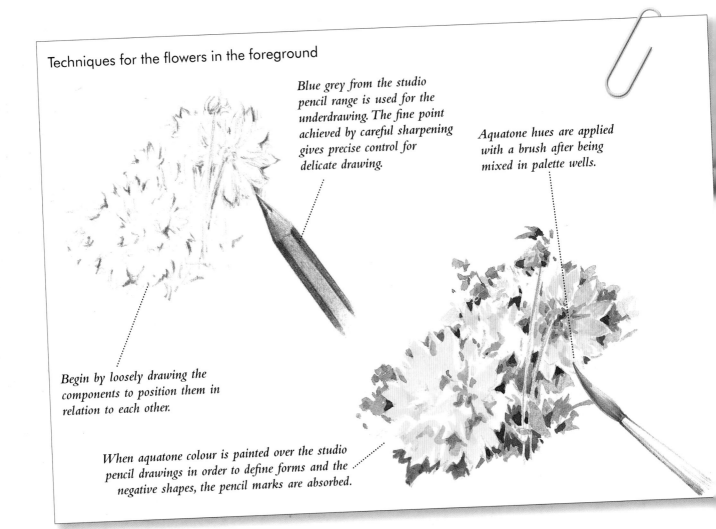

Techniques for the flowers in the foreground

Blue grey from the studio pencil range is used for the underdrawing. The fine point achieved by careful sharpening gives precise control for delicate drawing.

Aquatone hues are applied with a brush after being mixed in palette wells.

Begin by loosely drawing the components to position them in relation to each other.

When aquatone colour is painted over the studio pencil drawings in order to define forms and the negative shapes, the pencil marks are absorbed.

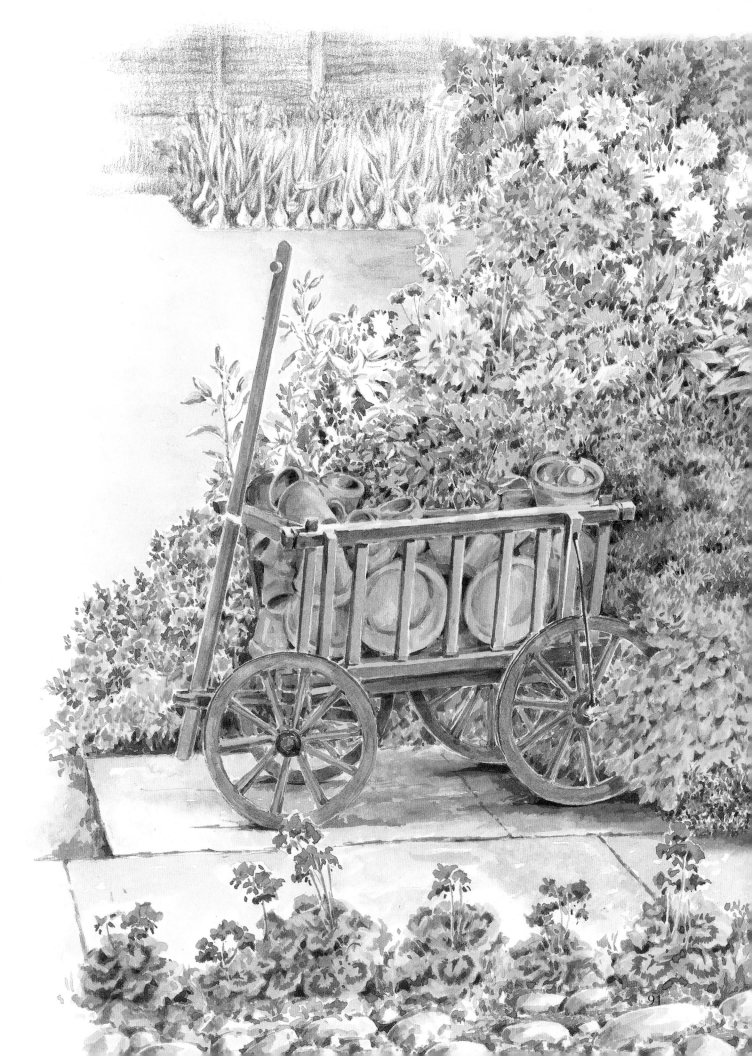

Creating impact

This enlarged detail of *Colourful Corner* (see page 91) will help you appreciate how the arrangement of simple positive shapes and the negatives that support them create the overall impression of massed blooms. Notice, also, that the darkest darks (although the smallest shapes) are vital if we are to achieve exciting contrasts. I enhance these towards the end of the painting and am careful not to overdo the darks. This ensures the white paper and pale tints of blooms and leaves are brought forward.

Some pencil ranges may not produce the richness in the darks that you require for your work. In these cases, negative shapes and shadows can be enhanced with the use of mixed media. For example, I often turn to my inktense range of pencils where indigo can be useful for overpainting into the darkest recesses, producing extra contrast and drama.

Graphitint pencil – dry application

Underdrawing in blue grey studio pencil

Leaving a slim area of untouched paper between blooms and background results in crispness and clarity.

The relationship of these two blooms is shown in the technique demonstration on page 90.

The darkest dark (shadow recess) shape is placed against untouched paper for maximum contrast.

Colour mixing

This is the range of twelve aquatone watercolour paint sticks which I used for *Colourful Corner* (see page 91). Also shown is a sherbet lemon inktense pencil, which was used for gentle glazing to brighten some areas.

The pink, yellow, blue and violet flowers have colours in the range that only need a touch of another to achieve their hues; however, as subtle, useful greens are often more difficult for some novices to achieve, I have shown below a few of my mixes for the foliage areas.

You can also see how a glaze of sherbet lemon from the inktense range can brighten the pale and translucent washes made with aquatone paint sticks.

Green mixes used in *Colourful Corner*

Sap green mixed with Venetian red produces a useful muted green.

The muted green mix can be diluted for further variation.

Bottle green mixed with zinc yellow produces a bright green.

The addition of deep vermilion to the bright green produces an olive green.

From top to bottom: burnt umber, Venetian red, emerald green, bottle green, sap green, ultramarine, dark violet, magenta, crimson lake, deep vermilion, middle chrome and zinc yellow aquatone watercolour paint sticks, and a sherbert lemon inktense pencil.

Emerald green mixed with burnt umber produces a rich green.

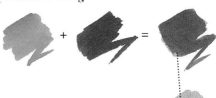 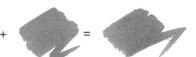

Again, the green can be diluted for lighter tones.

Adding ultramarine to the rich green creates another subtle hue.

A glaze of sherbert lemon over a green will brighten the translucent hues.

Muted green mix *Rich green mix* *Bright green mix*

Using more pigment will produce stronger colours.

93

Onion Flower

Beyond the flower head: a feeling for form

Drawing bulbs, tubers and rhizomes will enable you to appreciate the importance of an understanding of form and help to develop your observational skills. They were my favourite subjects to draw during plant study days at art college, and despite not being as colourful or arresting as flower heads or petals, their form is equally fascinating, and often packed with unusual textures or subtle colours.

Drawing these parts of the flower may encourage you to look further than just the flower heads we see in a garden and to consider what is happening below ground in order to produce such beauty. In turn, the time you put into drawing other parts of the flower will be rewarded and help produce beautiful flower drawings and paintings.

Close observation

Alliums – onions and their relatives – are summer border plants. Onion rows were included in my painting, *Colourful Corner*, as an introduction to this relationship, where the form of the resulting onion globe of flowers is echoed in the shape of the onion bulb. See the detail to the right. In this instance we can actually see the bulbs growing whereas, with the tubers and the iris rhizome on the following pages, they lie hidden in the earth.

It is only a short step from the vegetable onion flower ball to that of the colourful allium that can often be seen amidst other border plants. The starry purple flowers, each with six symmetrical petals, cluster in their ball atop a tall stem. Another type of allium, which has a conical head, may be compared in shape with the forms of the onion flower buds on the opposite page.

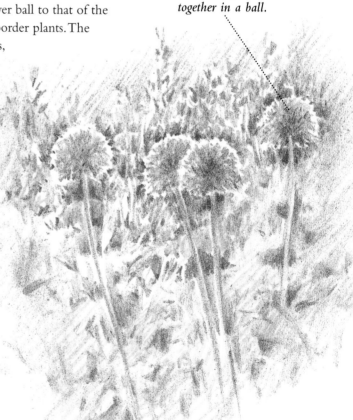

Detail of onion rows from **Colourful Corner**.

The small flowers cluster together in a ball.

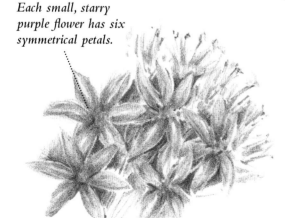

Each small, starry purple flower has six symmetrical petals.

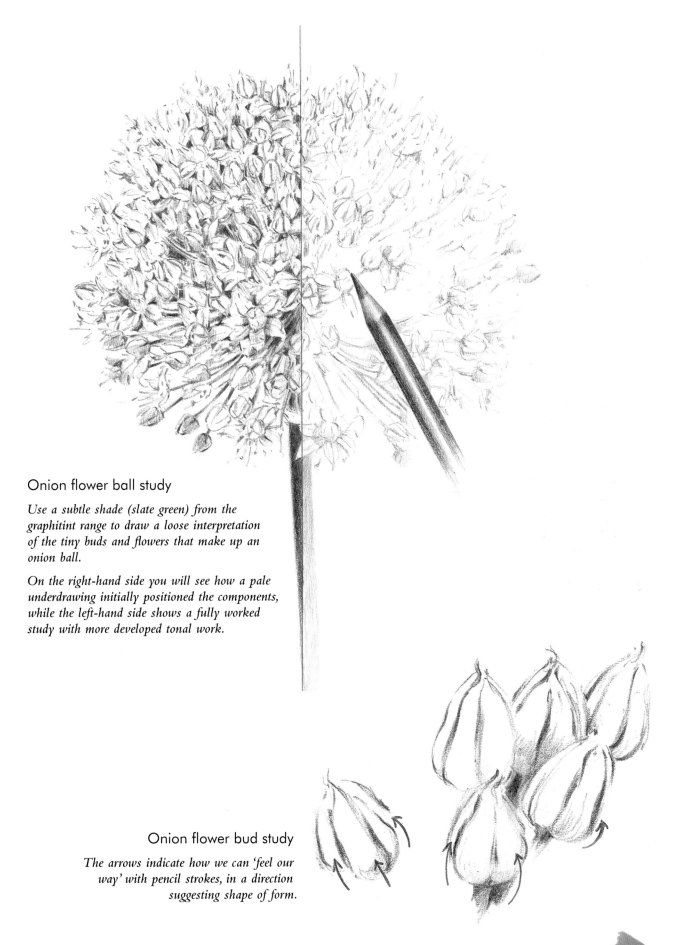

Onion flower ball study

Use a subtle shade (slate green) from the graphitint range to draw a loose interpretation of the tiny buds and flowers that make up an onion ball.

On the right-hand side you will see how a pale underdrawing initially positioned the components, while the left-hand side shows a fully worked study with more developed tonal work.

Onion flower bud study

The arrows indicate how we can 'feel our way' with pencil strokes, in a direction suggesting shape of form.

Lily Flower

Amongst dahlia blooms in my painting *Colourful Corner* are lilies, and I have included a study of a lily tuber below to show the diversity of these subjects and their fascinating forms. The formation of the components that make up the lily echo the formations seen in different flower heads, and it is comparisons like this that help us gain a deeper understanding of form.

With the skills developed through close study and painting of bulbs and tubers, painting flowers will become both simpler and more rewarding.

Method for painting roots and tubers

Alongside the lily bulb below a begonia tuber is shown for comparative purposes. Both are similar colours, and were painted using academy watercolour pencils along with the smooth hot-pressed paper. These materials are an ideal combination for reproducing the colours and textures of these formations.

Hold the subject in one hand while painting with the other. This is made easier with the use of a water brush and the academy watercolour pencils chosen for this subject. Touch the tips of the required colours and test the mixes on a palette well or scrap paper. This will allow you to paint the two different forms below by drawing lightly with the water brush. Start with pale hues at first and build up the picture gradually.

This detail of Colourful Corner *shows lily and dahlia flowers.*

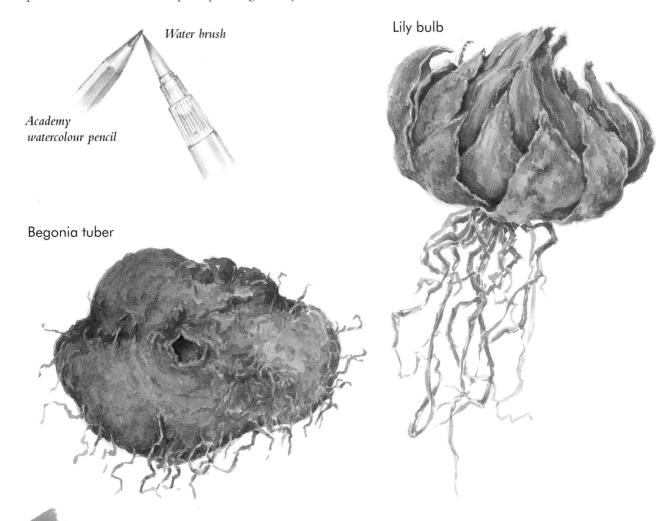

Water brush

*Academy
watercolour pencil*

Lily bulb

Begonia tuber

Lily petals

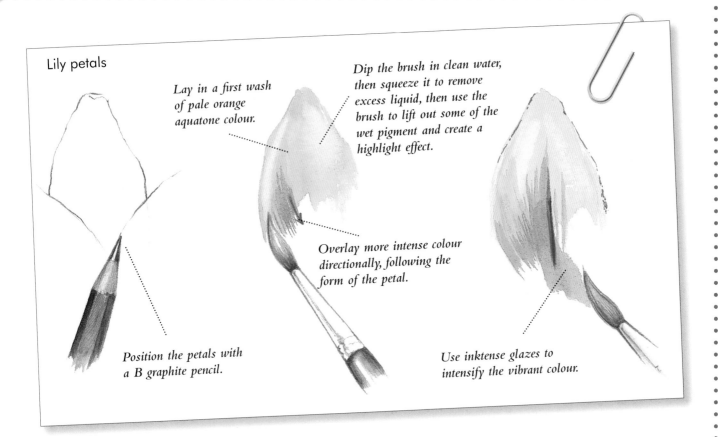

Lay in a first wash of pale orange aquatone colour.

Dip the brush in clean water, then squeeze it to remove excess liquid, then use the brush to lift out some of the wet pigment and create a highlight effect.

Position the petals with a B graphite pencil.

Overlay more intense colour directionally, following the form of the petal.

Use inktense glazes to intensify the vibrant colour.

Lily Flower

The glamorous lily flower that emerges from its rather bland bulb (see opposite) can add drama to both containers and garden settings. There are numerous varieties of lily, some more exotic than others, and I have chosen to paint one that is less exotic in order to simplify my demonstration.

I started with a graphite pencil outline which was erased once enough colour had been laid for me to no longer need it as a guide. Highlighted areas were created by lifting colour out using a damp brush before the wash had dried.

This study took a few hours to complete as I carefully overlaid each colour wash, wet on dry, to gradually build the impression, before final contrasts were cut in with darks that brought the light forms forward.

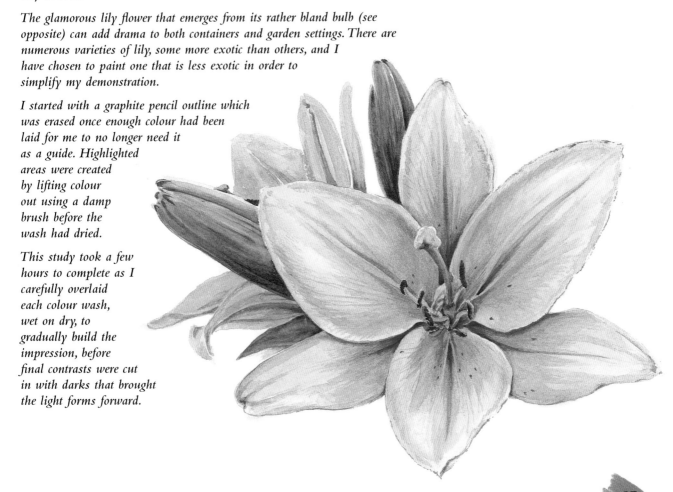

Garlic and Shallots

Whether interpreted loosely, as with the distant onion rows, or in delicate detail like this drawing of garlic, it is your understanding of the whole subject – not just the flower head – that will help your observational skills develop. This, in turn, will enable your impressions to become convincing.

This study of a garlic bulb shows the use of strong contrasts and reflected light. The varied pressure contoured strokes help to indicate the structure and form of the garlic bulb's components. Compare the marks made to develop the form on this study with the group of shallots opposite.

Start this study in 3B graphite pencil, and use studio colour pencil for the detailed work.

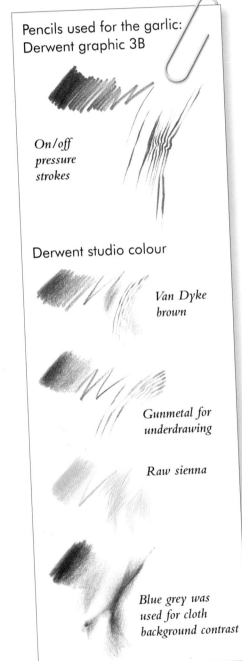

Pencils used for the garlic:
Derwent graphic 3B

On/off pressure strokes

Derwent studio colour

Van Dyke brown

Gunmetal for underdrawing

Raw sienna

Blue grey was used for cloth background contrast

Compare the loose approach for impression of onion rows using graphitint pencils (above) with the fine detailed drawing of garlic using the studio range (main image).

Place the darkest dark against the lightest light to provide maximum contrast and bring the light form forward.

Garlic bulbs are composed of various segments. The surface skin covering these cloves causes the external undulations visible here.

Use blue grey studio colour pencil to enhance the three-dimensional impression with a light edge, after the contoured shading and before the dark shadow recess.

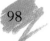

Group of shallots

The garlic bulb's components form an overall shape where clove segments fit together. This group of shallots also fit together but are all independent of each other and can be of various shapes and sizes. Another example of this type of arrangement is illustrated on the next page in the study of dahlia tubers.

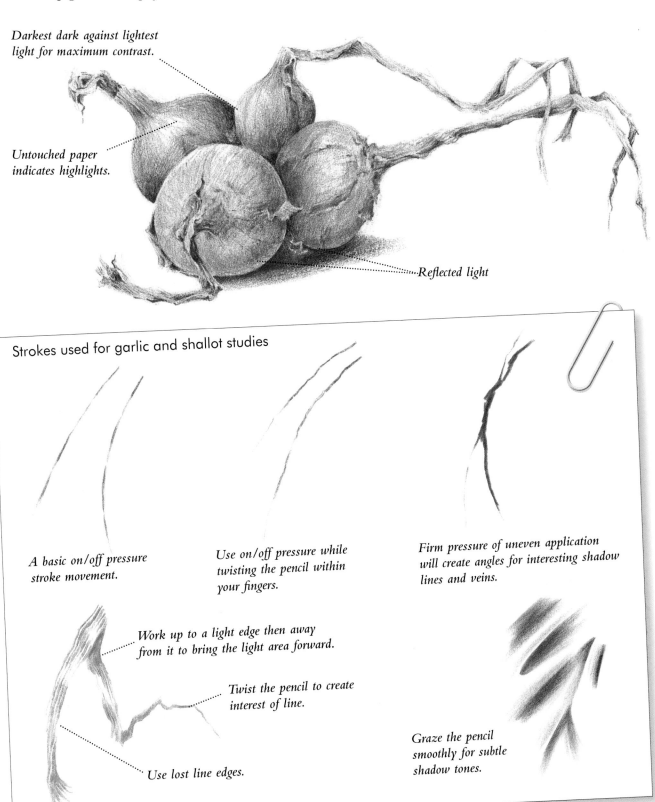

Darkest dark against lightest light for maximum contrast.

Untouched paper indicates highlights.

Reflected light

Strokes used for garlic and shallot studies

A basic on/off pressure stroke movement.

Use on/off pressure while twisting the pencil within your fingers.

Firm pressure of uneven application will create angles for interesting shadow lines and veins.

Work up to a light edge then away from it to bring the light area forward.

Twist the pencil to create interest of line.

Use lost line edges.

Graze the pencil smoothly for subtle shadow tones.

99

Dahlia

When visiting a garden centre looking for dahlia tubers to draw for this page I was thrilled to find such an interesting arrangement as this.

Standing at an easel was the easiest way to work as the tubers could be placed on a sheet of white paper upon a little table to look down at the diversity of shapes. The almost circular form against two tiny leaves – marked 1 on the investigative sketch below – and their relationship with the central area, marked 2, offered ideal starting points.

The investigative sketch is numbered to demonstrate where I started and how I worked through the drawing using guidelines from 'V' shapes (see pages 64–65) to help position components in relation to each other.

Regard for negative shapes is also helpful with this process. These have been coloured in green in the investigative sketch below.

Investigative sketch

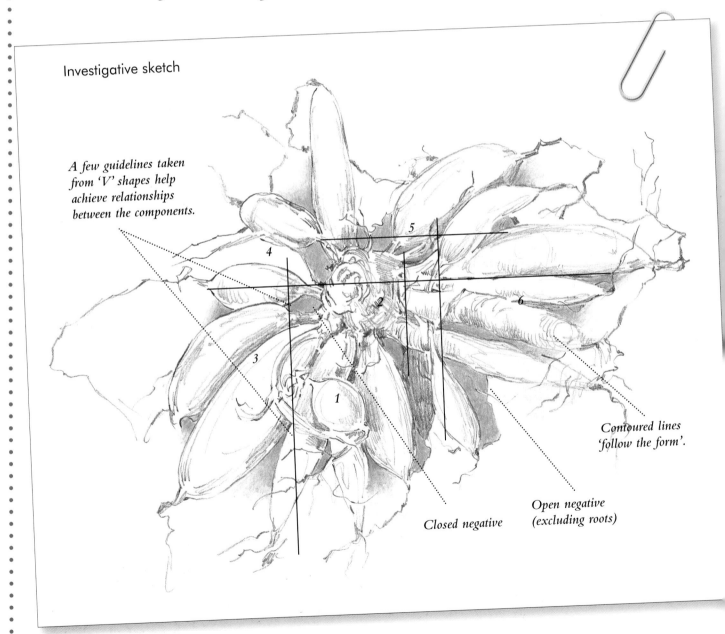

A few guidelines taken from 'V' shapes help achieve relationships between the components.

Contoured lines 'follow the form'.

Closed negative

Open negative (excluding roots)

Dahlia Tubers

For this picture, I used burnt umber, burnt carmine, bronze, raw sienna and grass green artists' pencils on heavyweight cartridge paper. Note the first signs of growth on the lower left-hand side.

Contrasts and 'cutting in'

From the simple shapes of dahlia tubers radiating from a central area, to the flowering forms of the petals shown below, we can see a great transformation. The lessons learned in drawing the tubers will inform your flower artwork.

For the finished dahlia flower, I have used academy watercolour pencils to demonstrate how just a few colours can work when overlaying and blending. Bright pink has been combined with carmine red for the petals, with a gentle overlay of raw umber in the deeper shadow areas to enhance the effect. Cadmium yellow and Naples yellow were applied in varied directions to provide delicate contrast in the central area.

Curved petals in the central area add interest to the form.

Dahlia Flower

When you want the external pale petals to contrast with a background hue you will need to 'cut in' carefully and crisply up to the edges, as seen at the point marked 'A'.

Alternatively, if the petals are to be presented against the white of the paper, you can define these edges using varied pressure upon the paper – producing an interesting line as shown at the point marked 'B'.

Rich dark tones behind light petal shapes provide eye-catching contrast.

B

A

For the background, apply dark green, then overlay it with raw umber and burnt umber.

For clear, crisp edges to the petals 'cut in' up to the slim light edge of the petal and shade away.

Bright pink, smoothly and swiftly applied in contoured strokes, will position petal shapes within slim edge lines drawn with carmine red.

Water features

Water features in gardens, echoing those we may see in the countryside, provide visual interest, contrasting textural effects of solidarity, and movement plus soothing sounds. We are unable to emulate the latter on paper; however, visual interest is in abundance and depicting the fluidity of water in contrast to rock structures and heavy boulders is an exciting challenge for an artist.

Having used the coloursoft range of pencils upon a textured paper surface for the picture of old boots on page 87, I wanted to show the versatility of these pencils by using them on the smoother surface of Derwent's sketching paper. Here I have created texture by the way the pencil strokes have been applied rather than relying upon the paper's texture. The smoother surface also enables falling water and ripple effects to be easily achieved.

In contrast to the complexity of content in this vignette opposite, below I have shown four examples to emphasise simplicity in the form of images that use just one or two colours for effective results.

Opposite:
Garden Waterfall

This water feature study shows a variety of iris that happily stands in or near water. Also, after looking at a variety of leaf formations in general, we can appreciate their diversity in a setting like this.

Notice how the colour of the rocks and boulders is reflected in the water. This, and the way pale mint and light sand colours have been used to unify certain areas, is an example of dry glazing to produce the desired effects.

This was worked in coloursoft pencils on sketching paper.

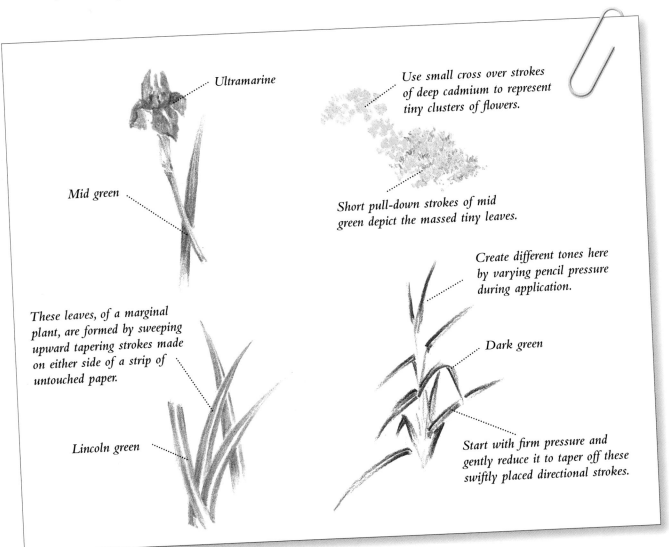

Ultramarine

Mid green

Use small cross over strokes of deep cadmium to represent tiny clusters of flowers.

Short pull-down strokes of mid green depict the massed tiny leaves.

Create different tones here by varying pencil pressure during application.

These leaves, of a marginal plant, are formed by sweeping upward tapering strokes made on either side of a strip of untouched paper.

Dark green

Lincoln green

Start with firm pressure and gently reduce it to taper off these swiftly placed directional strokes.

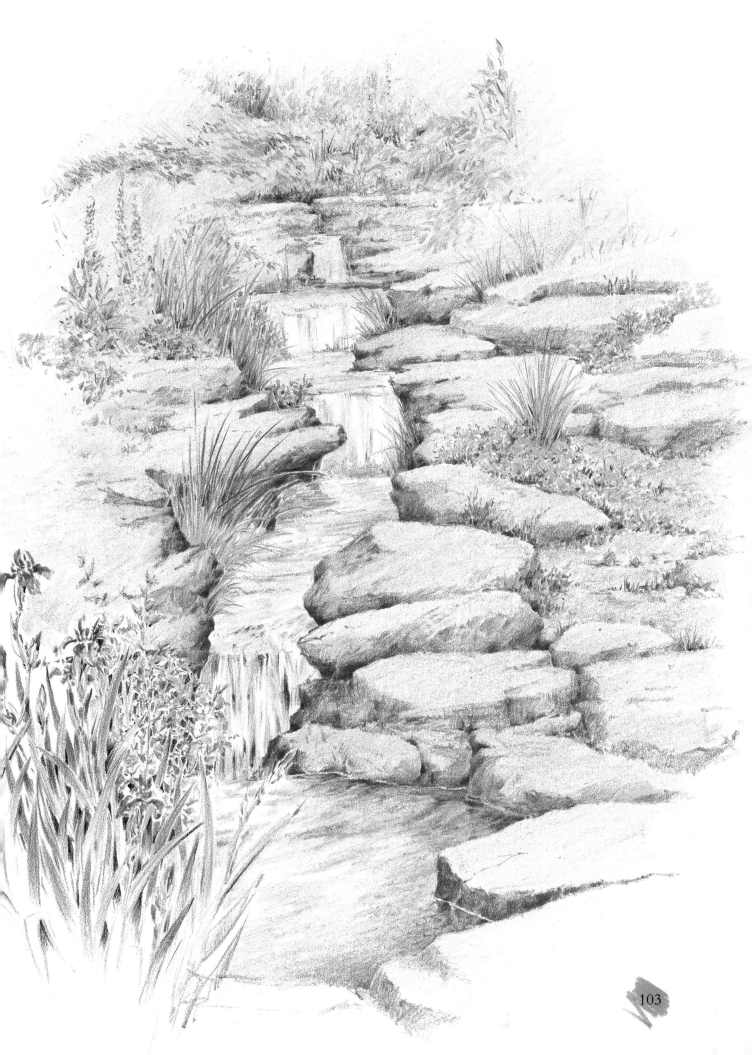

Overlaying to unify

Colour may be uniformly overlaid to knock back a distant area and bind the overall painting together. In the case of the water feature shown on the previous page, it helps to give an overall colour effect to the boulders on either side of the water, which emphasises the contrast between the two.

Here, a light sand colour has been laid across rocks and boulders as a gentle glaze.

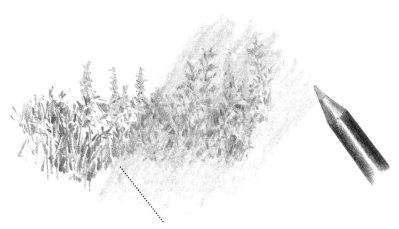

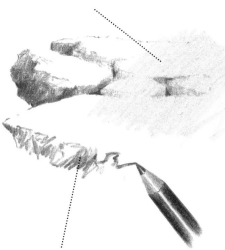

Here, the flowers are overlaid with a pale mint colour, covering an entire area. This unifies the colours and reduces the contrast between the tones, knocking back the area.

This is an example of underdrawing using the 'wandering line' technique, prior to unifying the shadow sides with a tonal glaze to create texture.

Falling water

I find that listening to the sound of falling water is helpful towards the depiction of movement in a still representation. It encourages the swift and bold application of strokes.

Initially, however, you may feel that working from photographic reference is a good way to understand the shapes we see and where highlights (retained white paper areas) are best placed in order to give the desired effect.

Horizontal lines turn into vertical application as the water drops off an edge.

Long, tapering, downward strokes are ideal for suggesting falling water.

Cloud blue with addition of pale mint and mid grey

Note that some water, particularly where it has fallen further, appears to twist.

Circular stippling is useful for suggesting bubbles as the falling water hits a surface.

Reflections and ripples

It is interesting to see both strong reflection and subtly toned ripple shapes when the surface of a pond is disturbed by movement of a waterfall or the activity of a duck, as in this example worked in outliner pencil with overlaid watercolour washes on smooth white drawing paper.

In the area that has been enlarged as a detail (see right), you can see the effect of cast shadows – where crisp contrasts add interest and drama.

We have so much to depict here: the movement of the water surface itself and that of anything resting upon it, like the lily leaves here; strong reflection shapes and gentle undulation of the surface away from the duck's activity. Some leaves rest dry, upon the surface, while others have a film of water partially washing over them.

Crisp contrasts are especially evident near the water lily flower.

Water lily study

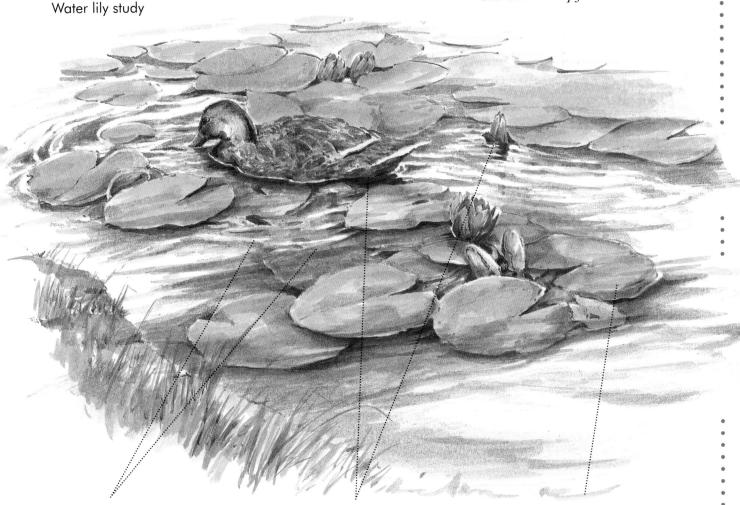

Varied hue and tone where the light catches the surface and also where some forms are beneath the surface.

Solid dark shapes help establish high contrast for a wet, glossy feel.

Ripple shadow shapes over objects give the impression of depth.

105

Leaves, trees and foliage

As trees and leaves play such an important part in our flower paintings and drawings in garden settings, it can be very helpful to make sketch book drawings in graphite of some of these formations. The examples on these pages show a variety of close studies of various leaves, while trees and distant foliage are investigated on pages 108–109.

Working sketches are those we make initially from which we can work in order to plan our composition. On our working sketch we can make adjustments as well as finding opportunities to include areas of interest and techniques that enhance the subject.

Areas of particular interest to look out for include lost and found effects, lost line edges, open and closed negative shapes, shadow shapes, and lines and markings that follow the forms to create a three-dimensional impression, but there are many more.

Flowing forms

Enclosed negative shapes *Open negative shapes*

Leaf formation

This detailed graphitint pencil study of a simple leaf formation is a good way to start studies for foliage around garden ponds and water features – where many of the plants have similar-shaped leaves.

Show the flat planes through directional parallel toning.

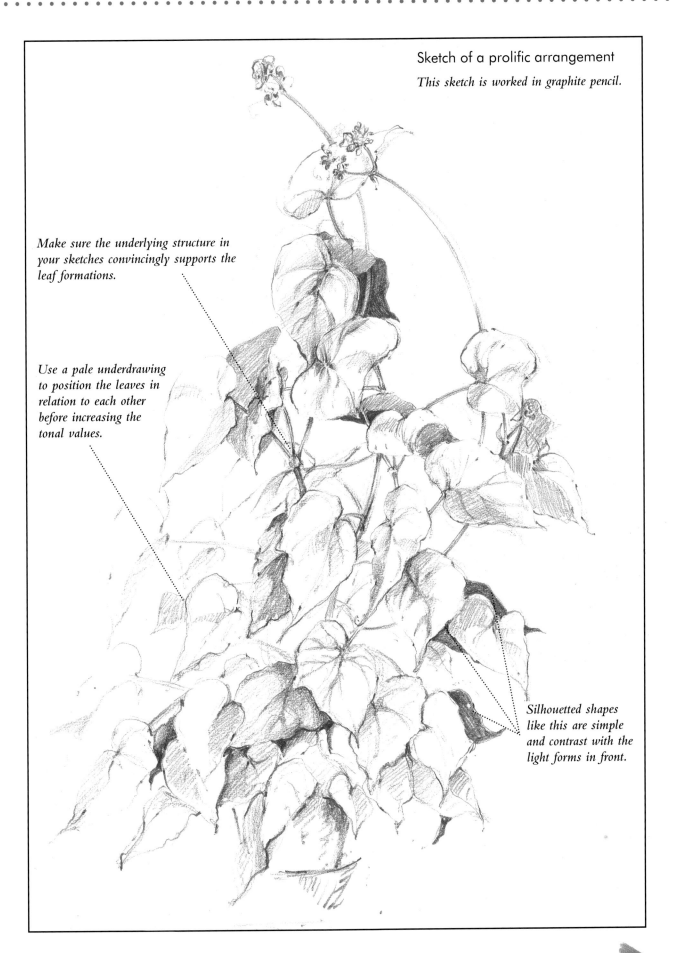

Sketch of a prolific arrangement

This sketch is worked in graphite pencil.

Make sure the underlying structure in your sketches convincingly supports the leaf formations.

Use a pale underdrawing to position the leaves in relation to each other before increasing the tonal values.

Silhouetted shapes like this are simple and contrast with the light forms in front.

107

Garden Corner

It is hard to imagine a successfully planted garden without a tree, or trees, playing a part in its construction. Sketch book studies of these interesting – and sometimes intricate – structures are a valuable addition to our visual diary. Their form and texture are unique in some species, while in others we can make comparisons to plant and flower structures as well.

Sketch book studies, initially drawn with graphite pencil, can be enhanced later with watercolour pencil washes. The example opposite is of the corner of a garden wall showing part of the garden behind. It was drawn with regard for various stroke applications relating to the subject being depicted.

Opposite:
Garden Corner

The conifers were placed using vertical zigzag strokes, both vertically – working down from the top – and horizontally – across the form from side to side. A wandering line, where constant contact was retained with the paper, positioned the flower stems and blooms. A similar application was used for the stonework of the wall before various flatter surfaces received parallel line shading.

The vignette approach allows white paper to contrast with the bright watercolour pencil hues in a pleasantly uneven way.

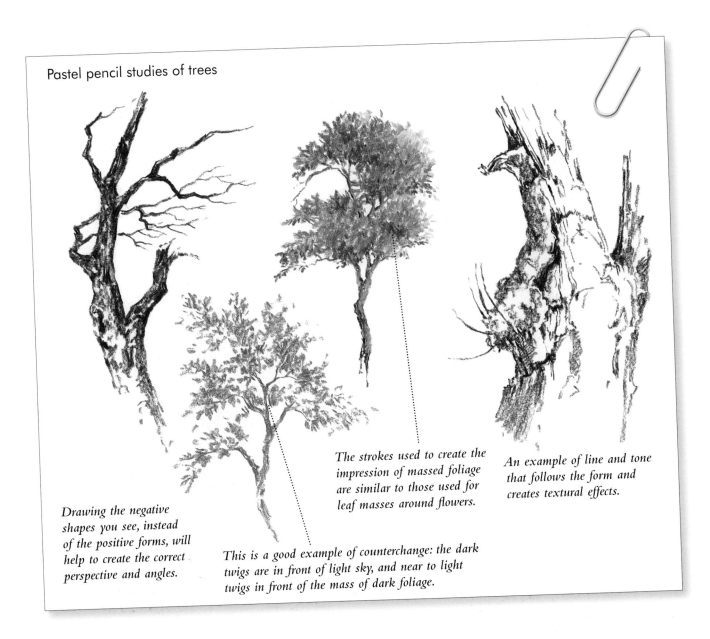

Pastel pencil studies of trees

The strokes used to create the impression of massed foliage are similar to those used for leaf masses around flowers.

An example of line and tone that follows the form and creates textural effects.

Drawing the negative shapes you see, instead of the positive forms, will help to create the correct perspective and angles.

This is a good example of counterchange: the dark twigs are in front of light sky, and near to light twigs in front of the mass of dark foliage.

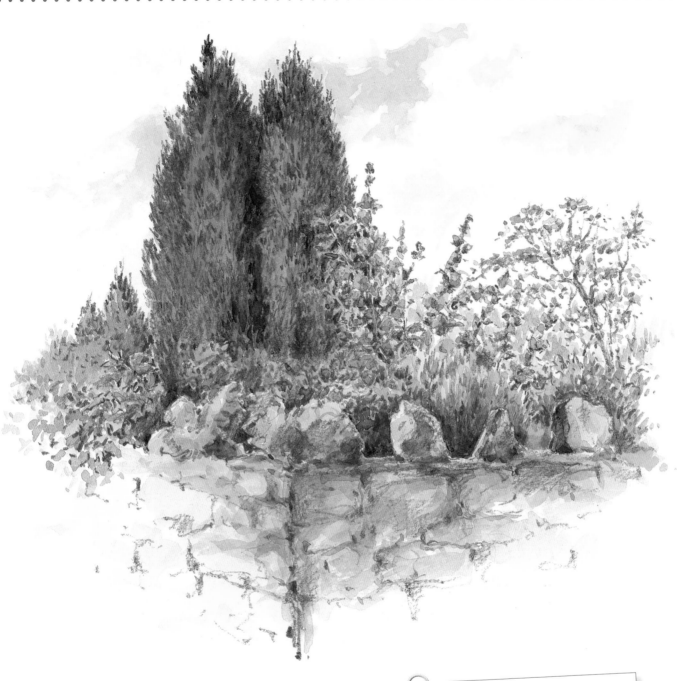

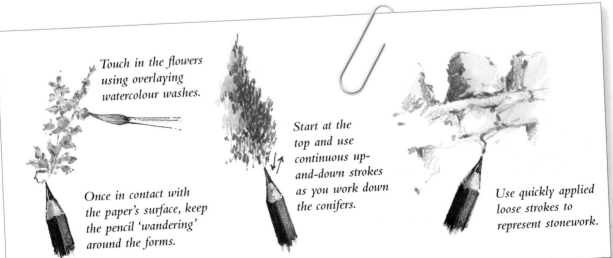

Touch in the flowers using overlaying watercolour washes.

Once in contact with the paper's surface, keep the pencil 'wandering' around the forms.

Start at the top and use continuous up-and-down strokes as you work down the conifers.

Use quickly applied loose strokes to represent stonework.

Rhododendron

Limiting your palette of colours can be very beneficial. It will allow you to concentrate more fully upon tonal values and it offers a challenge in colour mixing, as more thought is required as to the amount of pigment required to achieve certain hues.

I wanted to include in this book a study based purely upon the use of tonal values in a painting and chose inktense pencils for this purpose as they are such vibrant colours. The exotic appearance of rhododendron shrubs provides us with vibrant arrangements of spectacular flowers and rich green leaves. I picked a specimen from our garden and placed it at the side of my drawing board in order to make this study.

Although the flowers started to open more as I worked, resulting in a change of position, I had enough brush underdrawing in colour upon which to build the painting. This was made easier by the fact that I had chosen just two colours – finding that a mix of these would provide the third that was needed for a woody stem.

As reds provide us with a vast spectrum of tonal values and the rich hue of leaf green does the same, these two pencils were all that was needed for the exercise.

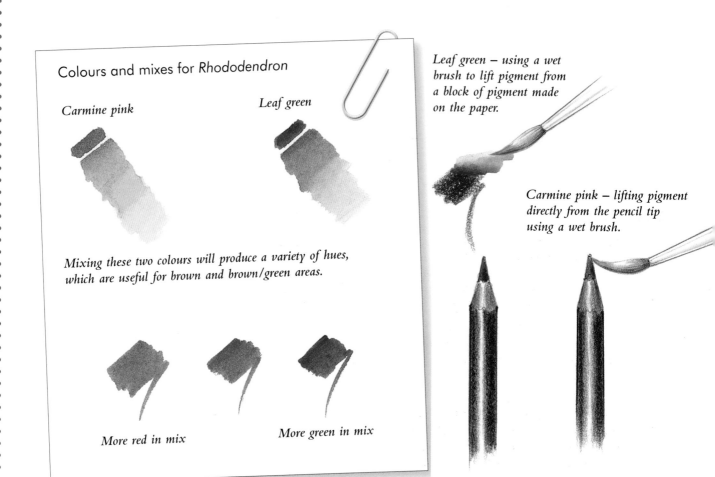

Colours and mixes for Rhododendron

Carmine pink

Leaf green

Mixing these two colours will produce a variety of hues, which are useful for brown and brown/green areas.

More red in mix

More green in mix

Leaf green – using a wet brush to lift pigment from a block of pigment made on the paper.

Carmine pink – lifting pigment directly from the pencil tip using a wet brush.

110

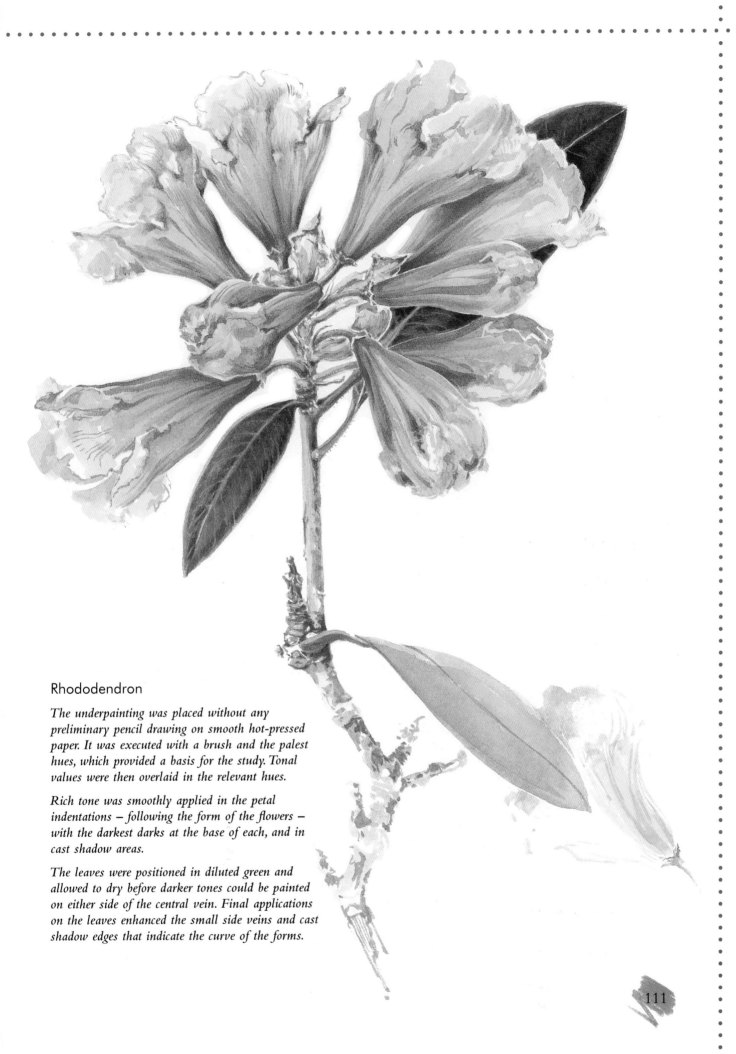

Rhododendron

The underpainting was placed without any preliminary pencil drawing on smooth hot-pressed paper. It was executed with a brush and the palest hues, which provided a basis for the study. Tonal values were then overlaid in the relevant hues.

Rich tone was smoothly applied in the petal indentations – following the form of the flowers – with the darkest darks at the base of each, and in cast shadow areas.

The leaves were positioned in diluted green and allowed to dry before darker tones could be painted on either side of the central vein. Final applications on the leaves enhanced the small side veins and cast shadow edges that indicate the curve of the forms.

111

Old Barn

Gardens, with their variety of areas of light and shade, are well suited to being depicted in dramatic monochrome. When drawing a purely monochrome study using pen and ink we are relying upon the marks we make to give the desired impressions. All of these marks are depicting shadow lines and shadow shapes, as well as edge lines where there is no contrast behind light forms. As explained on page 40, the interest of tonal and linear shapes relies on the use of varied direction and varied pressure strokes.

For garden settings like this example, where an old barn is surrounded by flowers, plants and trees, it is important to differentiate between the solid man-made form and the more transient organic forms. The same techniques and approach apply equally well to sheds, greenhouses and other structures in gardens.

This may be achieved by looking into the abstract shapes between forms, for example – the slim shadow lines between planks of wood and the contrasting narrow and wider shadow recess shapes between the stones of a wall. Massed foliage may be represented by crisscrossing your strokes, giving interesting dark negative shapes between light leaf and flower forms. Where dark leaf shapes are silhouetted against a light sky we can represent them exactly as we see them just as silhouettes.

A drawing executed with the brush may be developed from a loose interpretation like the sketch opposite. Using an inktense outliner pencil upon heavy weight cartridge paper I have loosely sketched the different textures of stonework, timber cladding, corrugated iron roof and various foliage masses. These were swiftly placed with line and tone.

You will see that many shapes are shown as dark silhouettes against a light background whereas, within the image of the barn, I have used the wandering line technique to indicate stone walls and varied pressure application to suggest shadow lines in the timber.

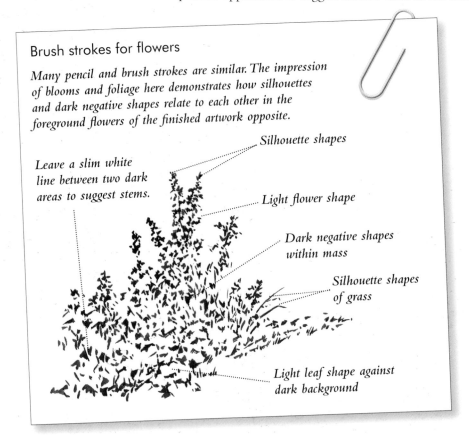

Brush strokes for flowers

Many pencil and brush strokes are similar. The impression of blooms and foliage here demonstrates how silhouettes and dark negative shapes relate to each other in the foreground flowers of the finished artwork opposite.

Leave a slim white line between two dark areas to suggest stems.

Silhouette shapes

Light flower shape

Dark negative shapes within mass

Silhouette shapes of grass

Light leaf shape against dark background

Working sketch

In this sketch the loose formation of the bed of flowers and foliage at the front guides the eye from one corner of the picture through and out of the composition. In the finished brush drawing below, the composition has been contained within a format.

Old Barn

Old barns can provide a wealth of interest for the artist as they are so often repaired with different materials over the years. I chose a Bockingford paper for this study and, using the liner-writer brush exclusively, defined the format with a black line in order to work right up to the edges and 'contain' the corners. I feel this approach gives a cosy feel to the picture suggesting that we, as the viewer, are beneath a canopy of foliage.

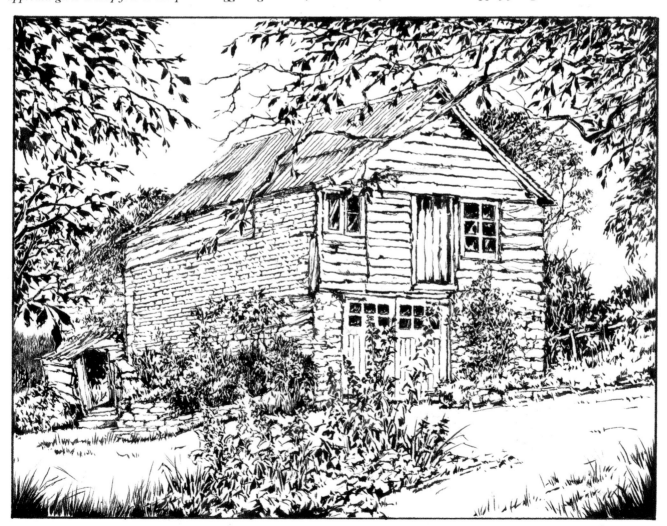

113

Iris

I have used the same colours and techniques for all of the studies on these pages to show how closely related flower representations are to other plants.

All use smooth broken pencil strokes to indicate strong highlights, the pencil leaving the paper's surface completely before being smoothly reapplied. Twists and turns of the pencil create interest of line in the upper part of the study and contoured parallel lines are just a few of the pencil applications that contribute to the final representations.

Sweetcorn study

Sweetcorn gives us an opportunity to practise a variety of strokes that also relate to flowers.

For this study I chose drawing pencils, as their creamy texture upon a lightly textured drawing paper worked well for the effect I wished to achieve.

Similar strokes to those used to depict the smooth iris petals opposite are used here.

Twist the pencil for these strokes.

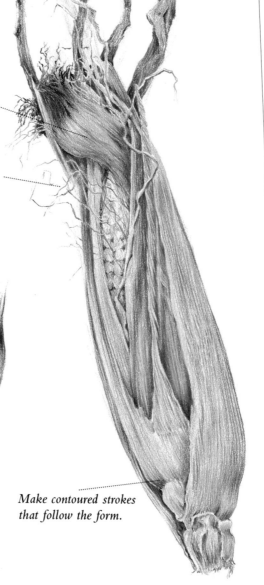

Drawing details like this will give you a greater understanding of structure and form.

Make contoured strokes that follow the form.

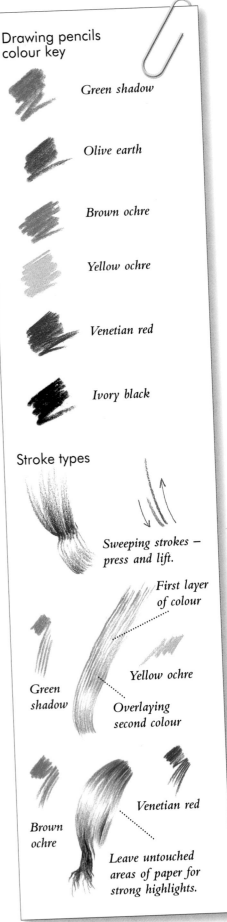

Drawing pencils colour key

Green shadow

Olive earth

Brown ochre

Yellow ochre

Venetian red

Ivory black

Stroke types

Sweeping strokes – press and lift.

First layer of colour

Green shadow

Yellow ochre

Overlaying second colour

Brown ochre

Venetian red

Leave untouched areas of paper for strong highlights.

Nearly Monochrome

These two studies of a delicate plant (below) and the bolder iris (right) demonstrate how the same pencil techniques can be used – whatever the scale. The sweeping strokes used here are the same as those used for the sweetcorn study opposite.

Where a bud or flower head is contained within an outer casing, we need to apply contoured strokes that follow direction of the form if we are to create a three-dimensional impression. This also means lifting pressure upon the pencil in areas where a highlight effect is required.

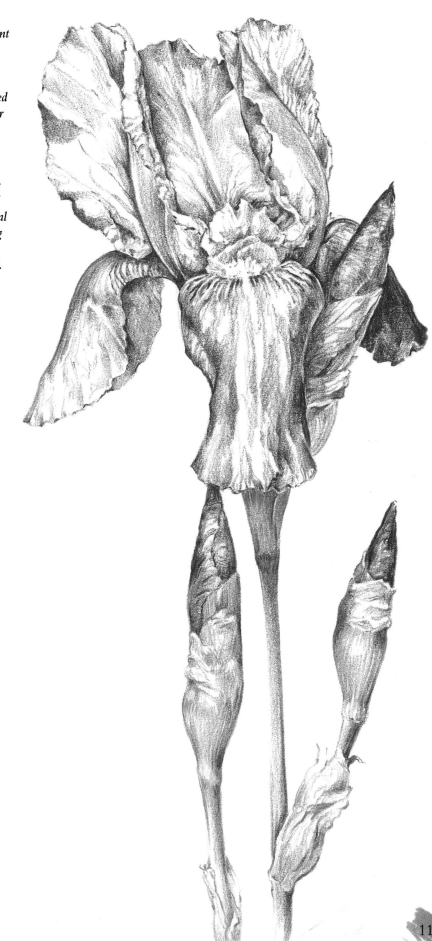

115

Iris in Garden

With numerous species and many colour variations, these tall, splendid plants can be seen amongst other plants in borders, as iris beds and as part of a water garden.

To draw an iris flower we need to consider the form at every stage, from rhizome to full bloom. In this project, we are looking down upon an iris which makes the bud at the top right-hand corner appear large in relation to the open flower – I therefore decided to exclude this by choosing an oval format.

This project offers you an opportunity to create working sketches that will provide valuable insight into how the flower grows, and how veins and markings can be used to define the form of your drawing by following their directions across the petals. In this way we can easily differentiate the petal coming towards us from the one on the left, facing the side, for example. Paying attention to the direction of your pencil strokes here will help you to describe the form of the final flower painting.

First stage

As explained earlier, studying the whole plant – from flower heads to root, including stems, bulbs, tubers and rhizomes as appropriate to the species – will help you gain an understanding of form, and appreciate how plants grow to eventually produce such stunning blooms.

Growing horizontally, iris rhizomes vary in size and grow at or below the surface of the soil. Make a study to familiarise yourself with the network of fine feeding roots and to help you understand how the sword-shaped leaves that grow in fans start to develop.

You will need

Watercolour paper: 300gsm (140lb) white Bockingford Not surface, 27 x 37cm (10½ x 14½in)

Inktense pencils: outliner, violet, light olive, willow, bark, white, sun yellow

Brushes: liner-writer, size 3 round, size 4 or 6 round

Graphitint pencils: green grey, ivy, meadow, cocoa, cool brown

3B graphite pencil and eraser

Heavyweight cartridge paper

Sketch book pad 165gsm (110lb)

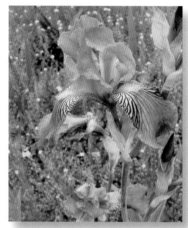

The source photograph

Iris rhizome – first green shoots

This study of an iris rhizome is executed upon a spare sheet of Not surface paper using graphitint pencils drawn dry on dry. This was followed by gentle water blending in selected areas.

Second stage

A working sketch is an important stage. With vertical as well as horizontal petal growth, positioning the first all-important negative shape can be a great help to drawing this iris. Looking at the source photograph you can see how that small shape – highlighted in red on my diagram below – places three petals in relation to each other. In order to establish the correct angle of the flower's growth just draw a vertical guideline from the 'V' shape at its base. Now you can see the 'shape between' that drop line and the flower stem and, by making sure you get that correct, you will have positioned the plant as in the photograph.

There are other 'V' shapes to look for that will help you place components and give strength to your drawing. The diagrammatic study below is worked in inktense outliner pencil upon heavyweight cartridge paper.

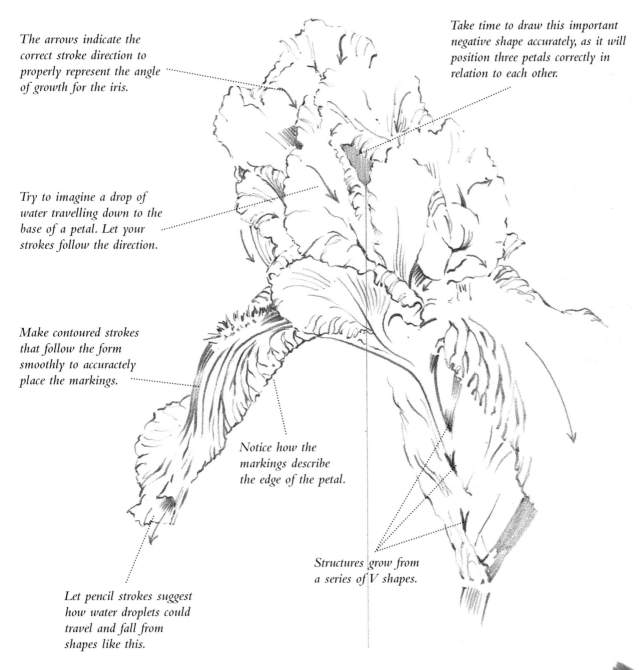

The arrows indicate the correct stroke direction to properly represent the angle of growth for the iris.

Take time to draw this important negative shape accurately, as it will position three petals correctly in relation to each other.

Try to imagine a drop of water travelling down to the base of a petal. Let your strokes follow the direction.

Make contoured strokes that follow the form smoothly to accurately place the markings.

Notice how the markings describe the edge of the petal.

Structures grow from a series of V shapes.

Let pencil strokes suggest how water droplets could travel and fall from shapes like this.

117

Third stage

There are a number of things to consider at this stage of our representation: the main image and how to give a three-dimensional impression, structure of supporting stem and relationships of buds, and treatment of the background area. Practise the details on this page using inktense outliner pencil on the heavyweight cartridge paper for clarity, then switch to the sketch book paper you will use for your working sketch (see box below).

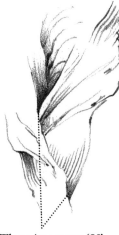

Varying pressure upon a sharp outliner pencil produces an interesting edge line.

Tone may be shaded to follow the form by working back into the petal from the edge.

Vein lines also follow the direction of the form.

Parallel strokes that follow the form help to define shape and texture.

These important 'V' shapes receive rich, dark tone to bring the light form forward.

Strokes with varied pressure produce different effects.

Lift pencil pressure completely from the paper as you work for a highlight effect.

Zigzag strokes give an impression of the tissue paper-thin casing around the iris buds.

Strokes for stems and leaves are similar.

Loose application of line and tone creates an effective background.

Inktense outliner pencil marks on sketch book paper

This paper is especially sympathetic to these particular techniques, so it is the best one for your working sketch.

The sketch book surface creates a softer feel than heavyweight cartridge paper, which is good for clarity when practising pencil strokes.

Make strokes with the wide chisel side of an inktense outliner pencil strip to suggest tonal areas.

The fine side of the same pencil strip is used for delicacy of line.

Fourth stage

Create a working sketch following the important considerations
annotated here, using a 3B graphite pencil upon the sketch book paper.

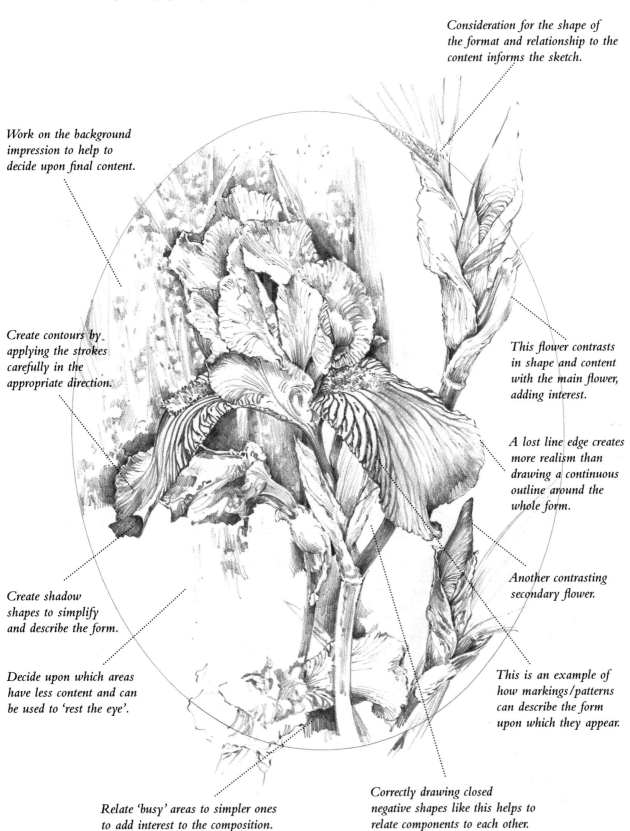

*Consideration for the shape of
the format and relationship to the
content informs the sketch.*

*Work on the background
impression to help to
decide upon final content.*

*Create contours by
applying the strokes
carefully in the
appropriate direction.*

*This flower contrasts
in shape and content
with the main flower,
adding interest.*

*A lost line edge creates
more realism than
drawing a continuous
outline around the
whole form.*

*Create shadow
shapes to simplify
and describe the form.*

*Another contrasting
secondary flower.*

*Decide upon which areas
have less content and can
be used to 'rest the eye'.*

*This is an example of
how markings/patterns
can describe the form
upon which they appear.*

*Relate 'busy' areas to simpler ones
to add interest to the composition.*

*Correctly drawing closed
negative shapes like this helps to
relate components to each other.*

119

Fifth stage

After making a working sketch it is a good idea to practise brush techniques. This page shows a few techniques that will help you to decide which paper to use, which brushes work best for the subject and the techniques involved.

In the same way that I vary pressure upon a pencil when using graphite I also do the same with a brush for linear and tonal work. This is explained in the exercises with a fine liner-writer brush for drawing and broader 4 or 6 brush for background impressions. I used violet and light olive inktense washes for these exercises.

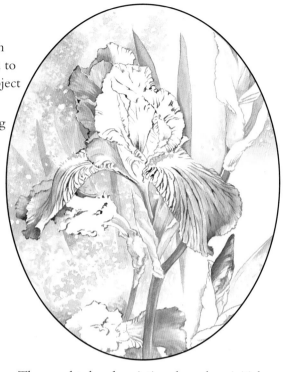

Petals

The liner-writer brush can produce very fine lines when only the tip is used and broader strokes when used upon its side.

The side of the very tip of the liner-writer brush can be used to paint the wider lines of the petal markings.

The completed underpainting shows how initial edge lines and markings are drawn with the brush before pale washes are overlaid.

Stems

Combine lines into a broad area.

Place less pressure on the brush tip when applying it on the surface for finer lines.

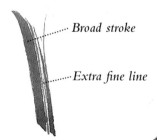

···· *Broad stroke*

····· *Extra fine line*

Practise following the contours of a form with narrow and broad strokes.

Background

Use willow and bark pencils in addition to the light olive for the background. Create an impression, rather than detailed interpretation of background forms.

An opaque mix of white inktense pencil is used for the background impression.

As an alternative, make lighter spots by touching clean water to the damp wash.

Imagine the white shapes and work the pigment around these.

Use a larger size 4 or 6 brush to achieve a textured impression for the background underpainting.

Glaze a dilute wash of warm hue over the entire background to unify the whole, allowing more hue and tone to be added and overlaid.

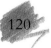

120

The finished painting

Washes have been overlaid to intensify hue and tone, with some areas of paper left untouched to represent the lightest lights. I also used white inktense pencil, both dry (for stem and petal highlights) and mixed with water (for the white dots in the background).

Flowers in the countryside

As a natural progression from the first two sections where we see flowers within the confines of containers or garden settings, this chapter will show you how to approach the enjoyable challenge of drawing and painting flowers with coloured pencils when viewing them in larger countryside habitats.

As with flowers in the garden, drawing flowers in the countryside gives us options for portraying blooms more loosely at a distance. This chapter includes meadow flowers and expansive fields of sunflowers stretching into the far distance as well as detailed images like the wild flowers on the opposite page and the buttercups in the project at the end.

We will also study a sunflower more closely, looking in detail at the flower in a later stage of development before seeding, to emphasise the importance of honing our observational skills.

Buildings play an important part in many countryside scenes, so those depicted in this chapter will give you an idea of how the presence of transient wild flowers can enhance our paintings of permanent man-made structures; and also how the inclusion of buildings – even seen in the far distance – can benefit our pictures of flowers.

Similarly, the way we use trees and woodland to add vertical interest to our pictures requires consideration. Seen as silhouette shapes along a distant horizon, or near enough to pick out their texture, trees can vary in size and position to enhance our pictorial compositions.

Your treatment of all these subjects will be personal to you – however, I hope my interpretations will offer you some new ideas to add to your own as you produce your own flower artwork.

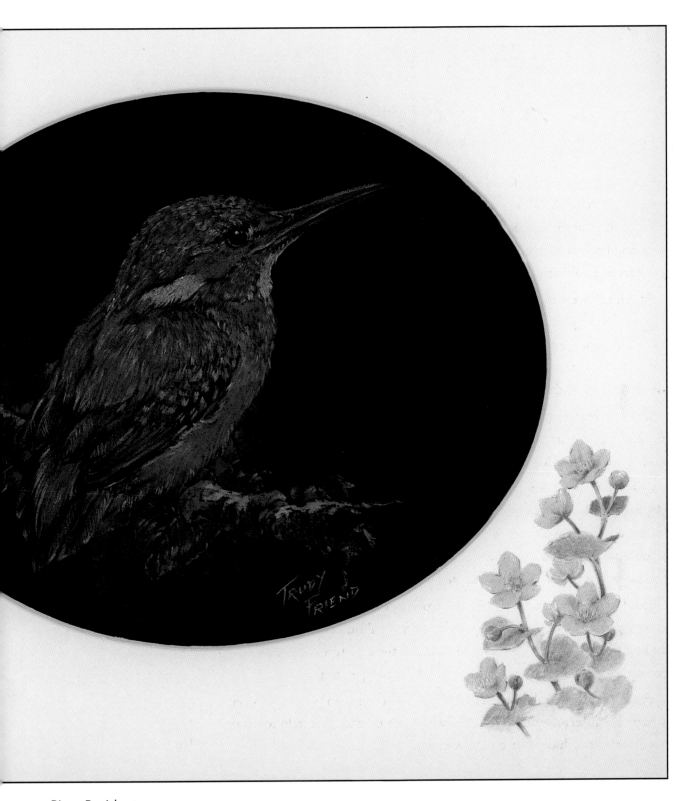

River Resident

Rivers and streams in the countryside harbour many water-loving flowers. These blue forget-me-nots and yellow marsh marigolds echo the vibrant blue and orange of the kingfisher, executed in pastel pencils upon a black ground (see page 129). A light mount enables delicate flowers to be drawn – showing the type of plants to be found in wet areas like river banks. Rather than limiting yourself to two studies, you could draw or paint many varieties of flowers on a mount that relates to the subject shown within the aperture.

Sunflowers

A field of sunflowers is a delight to the eye, with yellow 'faces' in the foreground blending into a yellow haze in the distance. Painting flowers in the countryside need not restrict you to the traditional landscape format. We can depict these bold flowers in various ways: below is an example of a traditional landscape format for the delicate impression of massed flowers, while opposite I have suggested something different – a round design for a plate.

I wanted to demonstrate how the aquatone paint sticks could be used for the delicate painting with watercolour techniques as well as for a bold colour drawing using them dry on dry.

The small study below, for which I used watercolour techniques, has received a gentle glaze of inktense sun yellow and sherbert lemon in certain areas, to brighten the effect. For the main painting I just touched the tip of required aquatone colours with a wet brush and mixed them in palette wells.

Field of Sunflowers

Aquatone paint sticks on smooth hot-pressed paper provided the basis for this picture, with inktense pencils used with the glazing technique to develop the painting.

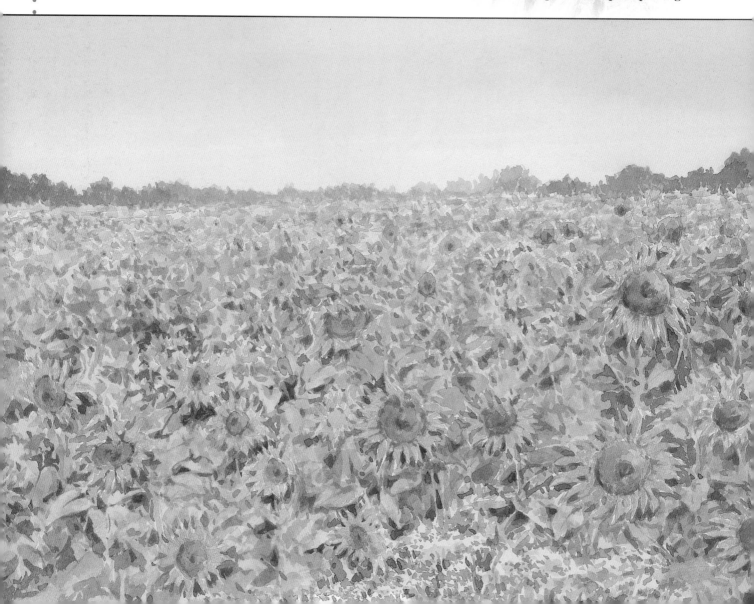

Design for a plate

In this design I have used the paint sticks as a drawing medium, creating textural effects by working on textured Not surface paper. I felt it would be an interesting exercise to create a design for a specific purpose. It started with a loose drawing, placing the flower heads in relation to a portrait format, with a suggestion of where leaves might be. I then drew around a couple of plates, to decide which size circle to work within.

The drawing was then built, dry on dry, with just the sky areas applied as a wash in order that I could use the white stick to position clouds after the wash had fully dried.

Sunflowers Encircled

Aquatone sticks used dry on dry on cold-pressed Not surface paper.

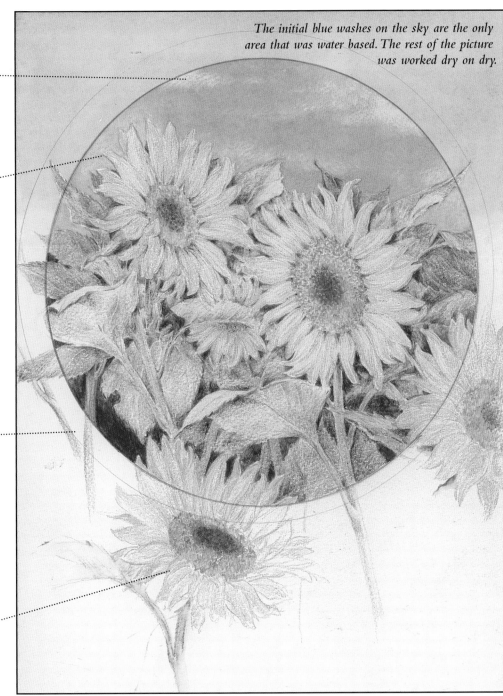

White clouds were made with a dry aquatone stick over a dry wash.

Another blue wash was overlaid on the first (when dry) to intensify hue.

These pencil-drawn circles indicate how I composed the design with regard for the positions of the flower.

The flowers were loosely sketched in before being developed to the level you see in the circled area.

The initial blue washes on the sky are the only area that was water based. The rest of the picture was worked dry on dry.

Going to Seed

After a flower's petals have wilted and fallen away it is interesting to observe the next stage of development – the start of seed creation. Fascinating forms and intriguing formations are apparent and this certainly applies to sunflowers for, at this stage, they can appear more complex and present us with subtle hue and tone to enjoy exploring.

It was this that led me to choose the drawing range of pencils for the main sunflower study shown opposite. Here, olive earth, crag green and yellow ochre provided the basic colours. These were enhanced by sepia tones. Zinc yellow and grass green from the artists' range were used to brighten and highlight by burnishing.

I took a series of photographs of this sunflower, including a close-up of the central area which provided an interesting formation for the sunflower formation sketch below. This is drawn with mustard, baked earth and charcoal grey inktense pencils, dry on dry. These hues were chosen because the colours were very close to those in the photograph.

Close observation and analysis of the shape and formation of flowers can be very advantageous for artists. Detail studies, where a single form is taken from a mass seen in the landscape, can help us through knowledge and understanding of the components to create a convincing representation of the subjects when observed massed together.

Tip

I find it helpful to make a number of small viewfinders from odd pieces of card that I use to place over my photographic reference when drawing complex arrangements like this. This prevents me from losing myself amidst so many similar shapes as I can concentrate only upon the area within the viewfinder. This can then be moved along to expose the next section if desired.

Detail study

Use baked earth, mustard and charcoal grey inktense pencils dry on dry upon sketch book paper for this study.

Retain untouched paper to indicate highlights.

Lightly draw components in place using mustard and baked earth inktense pencils, then develop the tone by overlaying.

Going to Seed

Using yellow and green artists' pencils as burnishing tools over the more subtle hues of the drawing range creates a brightness that contrasts with rich, dark shadow recess areas. It has also unified certain areas, reducing contrasts, and allowing subtle enhancement of veins on leaves in the final stages of the drawing.

Bluebell Wood

Pastel pencils may be effectively used upon a variety of supports that have some 'tooth' – this refers to the roughness or grain of the support. The grainy texture of pastel can be used to great effect for suggesting woodland texture when applied over a coloured ground. Below, I show my basic pastel pencil stroke applications for trees and foliage. The impression of bluebells at ground level may be given with similar strokes to those used for trailing leaves.

Foliage

Start the impression of foliage with overlapping strong angled strokes, in a crossover fashion, to form a mass.

Massed short strokes, with individual short strokes that flare out from the mass, can suggest direction.

Continuous application of crisscross strokes without lifting the pastel from the paper suggests dense foliage. Add individual marks to avoid making the foliage too dense.

Bark

Use zigzag strokes to suggest surface texture.

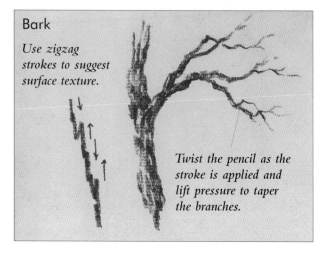

Twist the pencil as the stroke is applied and lift pressure to taper the branches.

Tip

You can practise these pastel pencil strokes upon any scraps of paper or card that have a tooth.

Investigative sketch

This shows the stages of building up a bluebell wood: the first stages on the left-hand side, and the right-hand side showing the trees at a later stage.

The tree trunks and foliage masses have been positioned in relation to a pathway in between, ready for the addition of masses of bluebells.

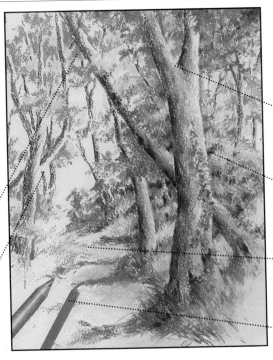

Block in foliage masses, paying careful attention to how they relate to the tree structures.

Position the tree structures in relation to each other, with regard for the negative shapes.

Build the darkest darks against the lightest lights for maximum contrast.

Create dark shadow shapes in the recesses for impact.

Apply pastel pencil strokes directionally, with regard for the way the foliage grows.

Pastel block may be combined with pencil.

Using tinted supports

The completed study of the bluebell wood has been worked on a black velvet paper and emphasises the strong contrasts of the pale bluebells. I retained some of the dark support to give drama to the scene. Compare this with the lightly tinted paper upon which the part-worked sketch opposite has been depicted.

Much of the dark ground has been left untouched by the pastel pencils in order to increase contrasts between tones of the image and the support. Notice also how a black support influences the contrasts between the highlighted and shaded sides of tree trunks and the shadow cast across the pathway.

Bluebell Wood

The strokes used for this study are mainly zigzags, crossovers and short directional marks with just a few longer, slimmer ones in the foreground.

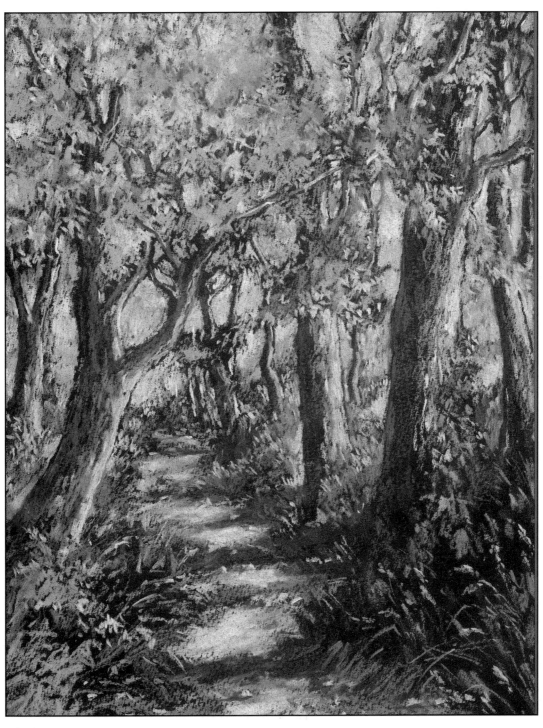

Wildflowers Among Ruins

There are many varieties of plants that happily grow wild on and in the crevices of old walls. In this piece I have shown two contrasting sizes. The red valerian is very prolific and attractive growing on and out of walls and the diminutive yellow corydalis offers bright contrast in its small clumps. An ancient wall in the foreground is bedecked with these pink and yellow blooms and a figure is taking our eye towards the towering ruin. I have lightly tinted the grass behind the flowers and coloured the figure in order to help lead the eye into the picture.

Examples of the graphite strokes used for the foreground flowers and background shapes are below. I have enlarged a flower and a bud from the valerian with the aid of a magnifying glass, as I feel it is an advantage to be aware of the tiny components as well as the impression we see from a distance.

Red valerian flowers details

Close studies made using a magnifying glass of small flowers such as the water forget-me-not (left) or red valerians (below) will familiarise you with the form and structure of the flower, which will help to inform the overall impression when seen in your work.

Graphite pencil strokes

Graphite shading over a wandering line drawing.

The background conifers were positioned using vertical zigzag strokes.

Combining colour and monochrome

Stonework is interesting to draw and I have chosen to depict the ruin in monochrome, as a graphite drawing, to demonstrate how the addition of colour in the foreground can enhance a study like this.

Coloursoft pencils used for foreground flowers

Deep red Mid green Lime green Deep cadmium Brown

Coloursoft pencils used for monochrome tones

Petrel grey Dove grey

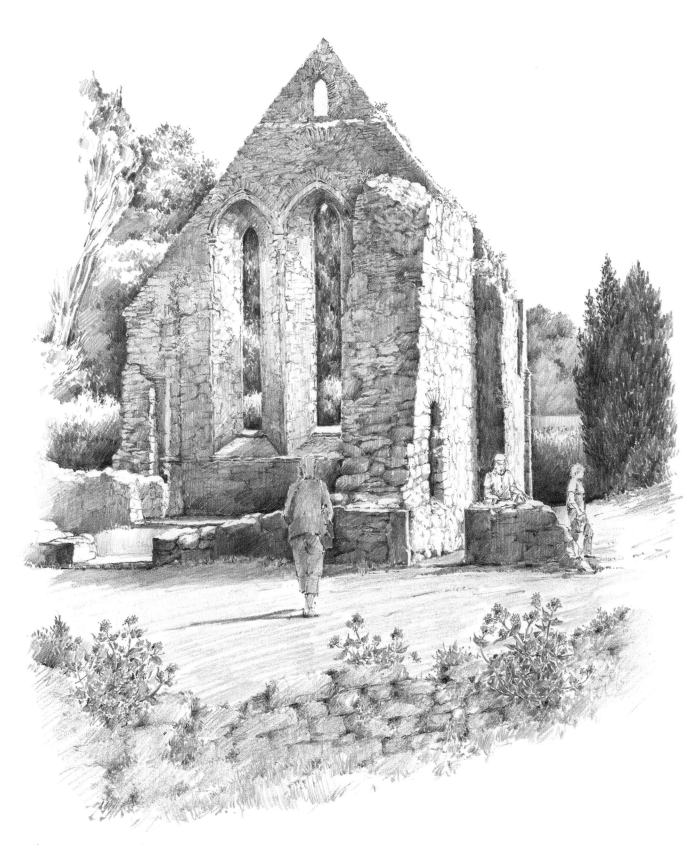

Flowers Amongst Ruins

Worked with graphite and coloursoft pencils on lightweight sketch pad paper, this vignette combines monochrome and colour, an approach that allows the foreground flowers to 'lift' the ruin and prevents the mood from becoming sombre.

Meadow Flowers and Cottage

Masking fluid can be of great help when you want to include masses of wild (or garden) flowers in your painting. On pages 42–43 I demonstrated a masking fluid technique using an old, fine brush as applicator. For the method example below I have used a soft masking fluid applicator instead of a brush – either will work well.

Three stages of development are explained below. The example here shows the effects achieved when removing the masking fluid at each stage, but it is important to note that the masking fluid usually remains in place for all three stages and is only removed when all are complete.

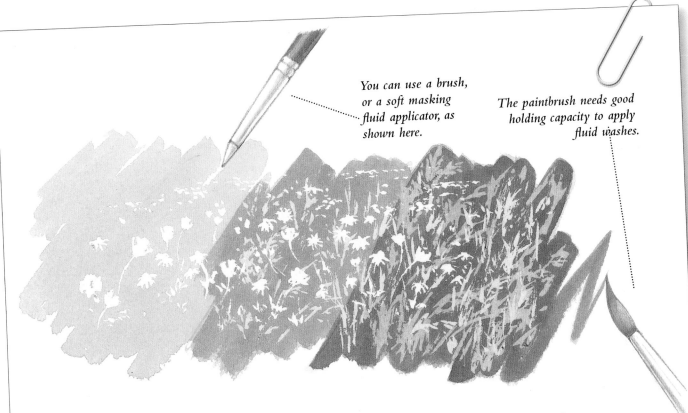

You can use a brush, or a soft masking fluid applicator, as shown here.

The paintbrush needs good holding capacity to apply fluid washes.

First stage: flower heads

Apply the masking fluid and allow it to dry before washing over it with diluted inktense colour. Once dry and removed (this is usually only once all three stages are completed), the white paper shapes revealed will represent flower heads and slim stems.

Second stage: leaves and stems

Apply more masking fluid over structural areas and flower heads, then wash over the area with a darker hue. If removed at this point, the masking fluid will reveal the pale first wash colour, which represents grasses, leaves and other structures, while the flower heads remain white.

Third stage: depth

A third, still darker, wash can be applied as before. When removed, it will reveal blocks and lines of the paler greens, into which you can work detail for the final overpainting.

Note

Remember, the masking fluid is usually removed only after the third stage is completed.

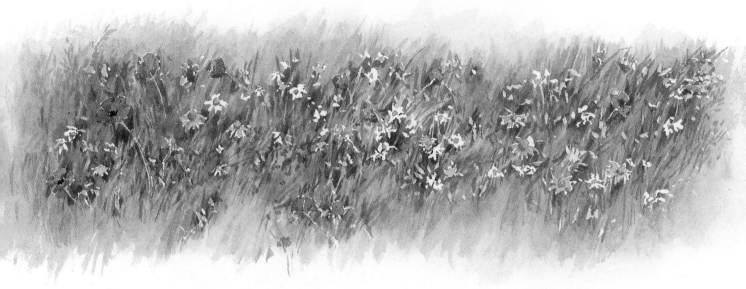

Meadow flowers vignette

Inktense pencil washes were used over masking fluid as described opposite for this vignette. Inktense pencils were chosen in order to obtain vibrant hues for the flowers and so that a bright pale green and yellow mix could be used to glaze surrounding foliage areas. This accentuates the contrast between the two.

Preliminary sketches for cottage

Here are two sketches of a cottage, intended as a background to support the wild flowers amongst long grass in the finished picture. Both were drawn in ordinary black ballpoint pen upon copier paper. Dry inktense pencil was then worked over each in order to see how green foliage areas would relate to the building's shapes and textures within the composition.

The arrows show how the eye is encouraged into and around the composition. Note the interesting shape between the wall and doorway, and the relationship between the window, tree and wall.

Meadow Flowers and Cottage

Rather than just show meadow flowers in the context of fields with hedgerows and trees, I have placed them in front of a derelict cottage to add interest to the scene. Perhaps, as the cottage deteriorated, nature took over and added the beauty of these wild flowers. Whatever their origin, we can appreciate their vibrancy and freshness in contrast.

The cottage, wall and trees were painted first using watercolour techniques. The grassy area with flowers was then painted in the foreground, using the technique shown on page 133 with a small brush or masking fluid applicator.

Notice how some of the poppy flower shapes in the painting have a slim white paper edge around them. This gives a crispness up to which the background shapes and glaze have been painted for maximum contrast and effect.

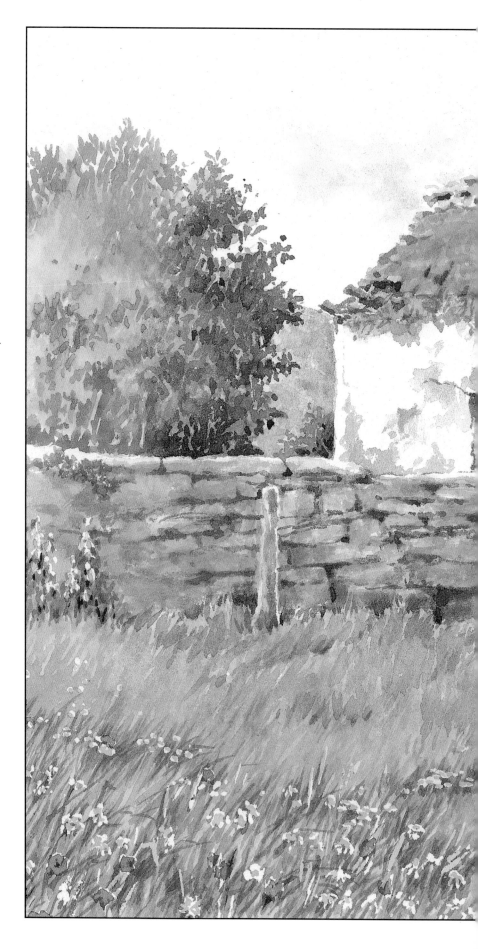

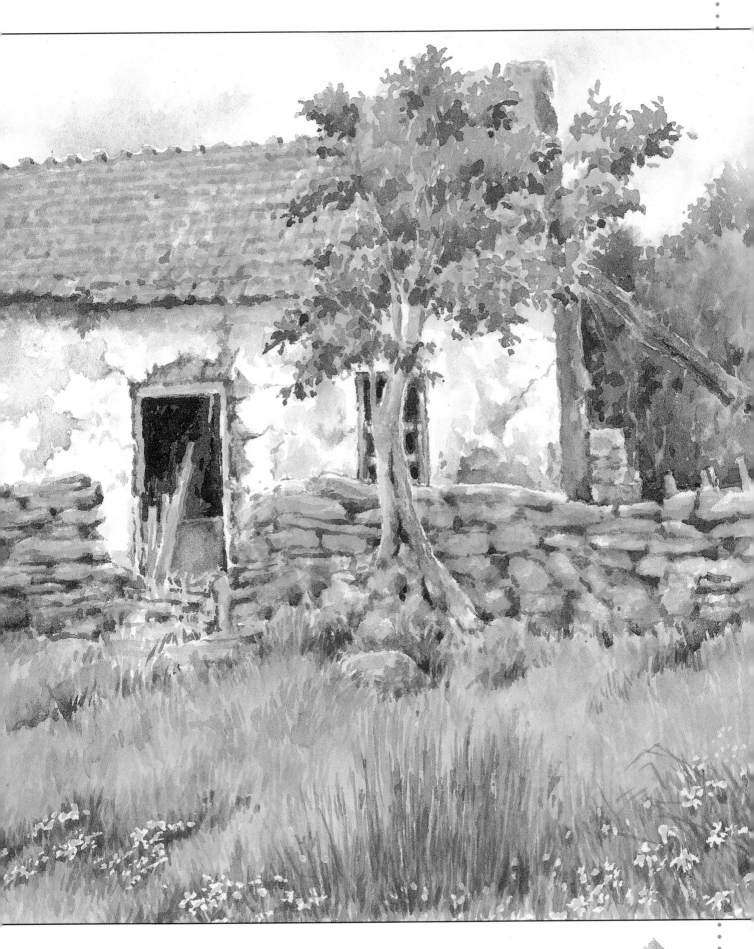

Buttercup Meadows in Farmland

In summer months we can often see plain, grassy meadows transformed by buttercups into swathes of vibrant yellow, which contrast beautifully with the shapes and colours of surrounding trees and farm buildings. This is an opportunity to use inktense pencils on a tinted paper – Bockingford Oatmeal in this case – where the white pencil can be used for the walls of buildings and mixing a pale blue sky.

Although we may compose a picture with care before starting to add colour, there may be times when we feel areas of the artwork do not have enough interest or content to warrant retaining our original choice of format. This study of buttercup meadows in farmland, originally envisaged in a rectangular landscape format, has been used to demonstrate the method of cropping our pictures by cutting out the area that works compositionally and discarding surrounding work.

The interesting shapes of the sky between the trees and edge of format are enhanced by the oval format.

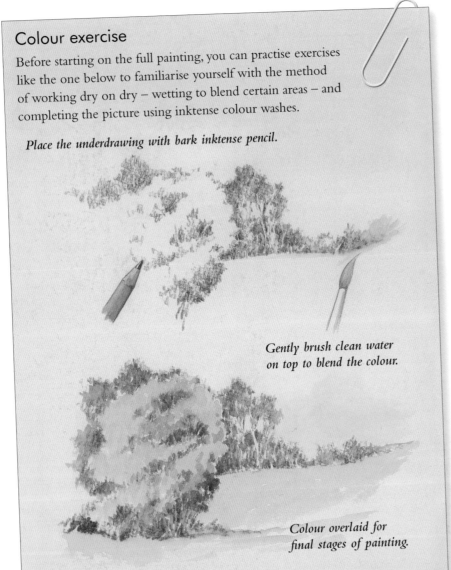

Colour exercise

Before starting on the full painting, you can practise exercises like the one below to familiarise yourself with the method of working dry on dry – wetting to blend certain areas – and completing the picture using inktense colour washes.

Place the underdrawing with bark inktense pencil.

Gently brush clean water on top to blend the colour.

Colour overlaid for final stages of painting.

Adapting a new format

First of all I wanted to simplify tree images with regard for shape and the use of counterchange. I have annotated the investigative sketch below to explain this and how I chose to crop the final, rectangular shape of the painting.

I chose outliner inktense pencil for this sketch and used bark inktense pencil for the underdrawing in the final painting. The oval has been drawn over this sketch to show how the original painting was eventually cropped to create the format you see on the next page.

Notice how counterchange has been used here. The lower part of the tree trunk appears white against the dark foliage behind it, while the branches are dark against the light sky.

The angle of this tree silhouette and the way a hedgerow beneath relates to the trees in front offered a good position for the edge of the format to cross.

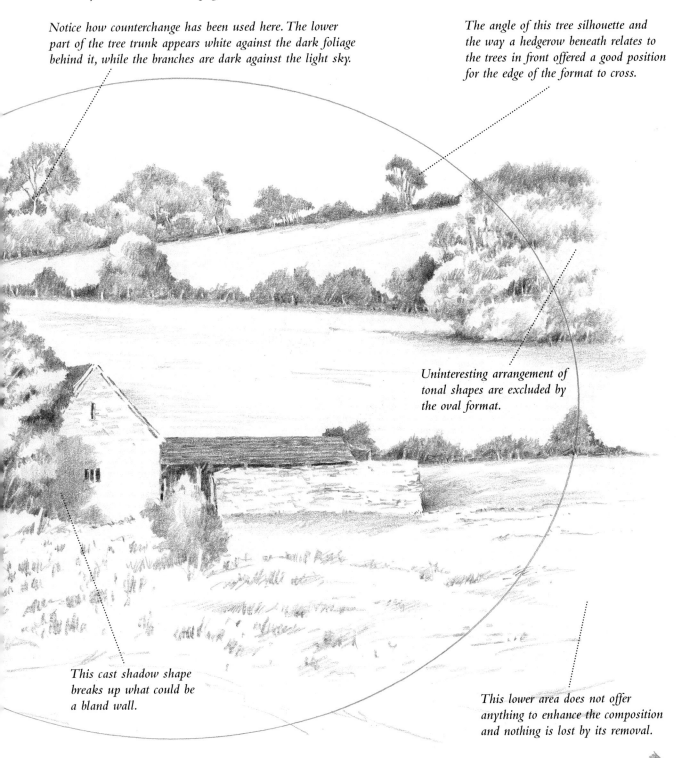

Uninteresting arrangement of tonal shapes are excluded by the oval format.

This cast shadow shape breaks up what could be a bland wall.

This lower area does not offer anything to enhance the composition and nothing is lost by its removal.

137

Buttercup Meadows in Farmland

Worked in inktense pencils on oatmeal-tinted Bockingford paper, this painting was originally within a rectangular format. However, the importance of the main image could not be fully appreciated – with rather bland areas of grassland taking up so much of the composition. I also felt that the vibrancy of massed bright yellow buttercups would have more impact if it were confined to close proximity with the buildings, and in relation to the main tree shapes.

I painted the main components using the method shown on page 136. Because I was working on a tinted support, I needed to make sure the vibrant sun yellow inktense pencil would depict buttercup fields. To achieve this, I used white acrylic paint, a fine brush, and gently positioned the areas to be painted yellow with this medium. Sun yellow was then placed on top of this (very limited) white undercoat for the flowers, which gives the sense of swathes of buttercups.

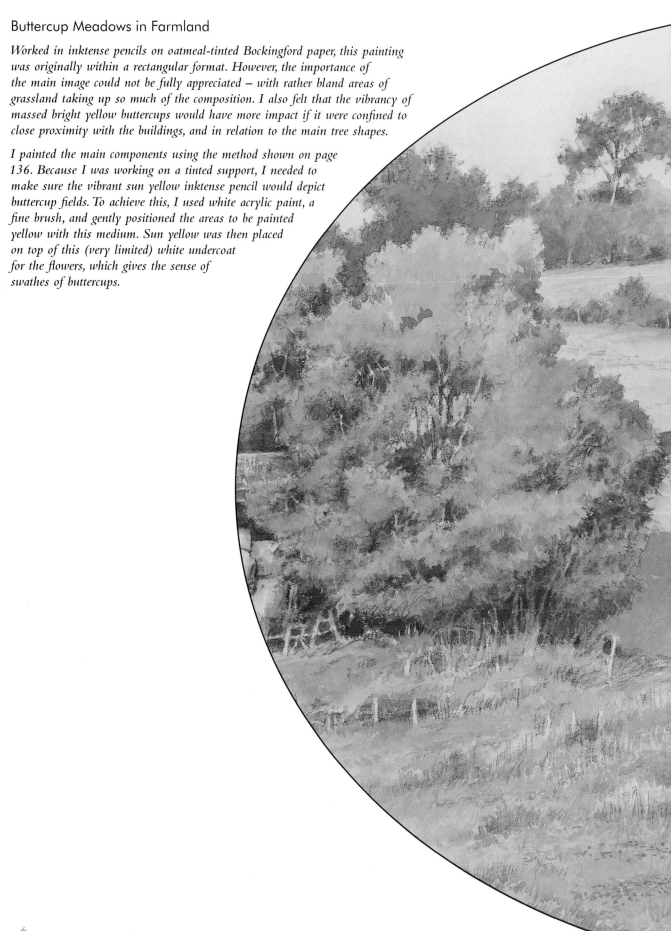

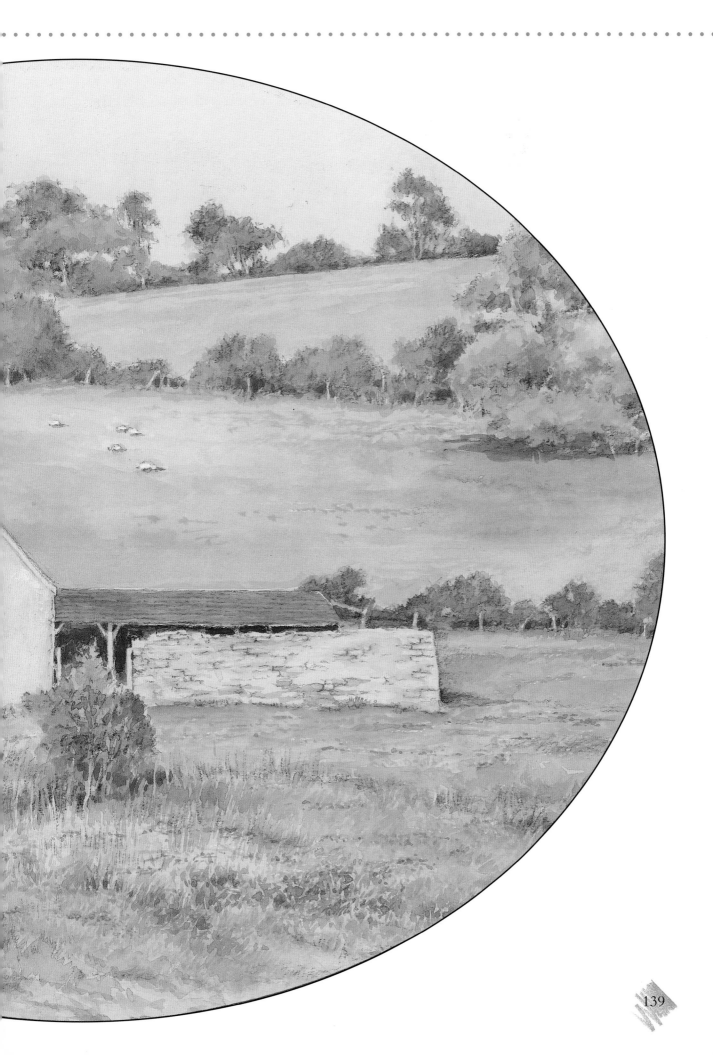

Buttercup Meadow

My final demonstration, of buttercups, is presented in a different way from the other two as I want not only to show a typical scene in which they may be found growing in profusion but also a way of interpreting the mass when seen much closer.

Rather than a tight, detailed approach, aim for an overall impression. In order to do this, use the 'lost and found' approach. This is when our eye takes in the intricacies of a form in one area yet loses it in another. In the completed picture I have also left areas of untouched paper for the clover heads so any detail there is lost. This approach creates a feeling of spontaneity; however, you will see in my diagrammatic example that much thought is given to the process.

You will need

Watercolour paper: 300gsm (140lb) white Bockingford Not surface, 21 x 29cm (8¼ x 11½in)

Watercolour pencils: may green, bottle green, raw umber, sepia, copper beech, burnt carmine, indigo, deep cadmium, Naples yellow, middle chrome, sap green, mineral green

Inktense pencils: sun yellow

Brushes: size 3 round, size 6 round

Utility knife to sharpen pencils

Palette with wells

First stage

Unlike the other demonstrations, I have not used a particular source photo. Instead I have studied buttercups and white clover on my dog walks, and made sketch book notes as well as working from specimens brought home. Familiarise yourself with the flowers you want to depict as much as possible for results that are true to life.

Lost line edge

Seeds of grasses are represented with short pulled-down zigzag strokes.

Use firm pressure initially, with upward contoured movement to follow the form.

The lost and found approach is well suited to white clover.

When making quick sketches, try to create a sense of movement, using loose strokes to establish long, slender stems on which to position massed blooms.

140

Second stage

The most important part of the finished composition is the central area of buttercups and clover. Use watercolour pencils to create a close working sketch of this area to practise building up the work, and to provide you with a good basis for development.

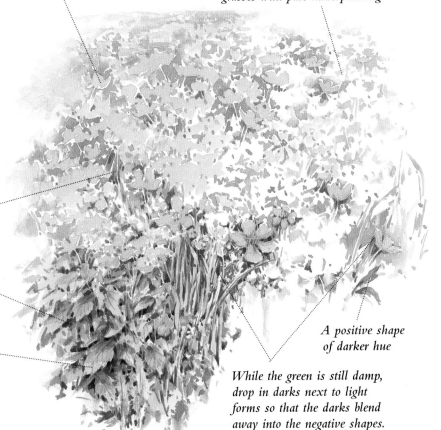

Paint the yellow buttercups as simple flat shapes.

Establish the negative spaces between flowers, stems, leaves and grasses with pale underpainting.

Apply vertical strokes swiftly to suggest grasses, and indicate stems by working up to and away from light strips.

Quickly and loosely apply paint in crossovers to develop the impression of massed foliage.

Place pale glazes upon areas of untouched paper for the lightest lights.

A positive shape of darker hue

While the green is still damp, drop in darks next to light forms so that the darks blend away into the negative shapes.

For intense colours you can lift pigment directly from the pencil.

Third stage

Working from life or a photographic reference we may choose to use artistic licence to edit in or edit out content in order to create more interest or to improve the composition.

If you compare the detail from the working sketch (left) with the detail from the completed painting (right) you will see that I have used artistic licence to change the content in the foreground. The predominance of green has now been relieved by the inclusion of white clover and some warmth of grasses in seed. You can see within the circled area how small dark negative shapes bring the light forms forward.

Fourth stage

In order that you can understand and practise the techniques that lead up to the introduction of final contrasting darks, I have approached the fourth stage of this demonstration diagrammatically.

Green mix

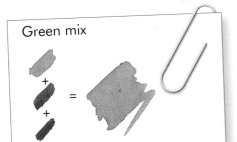

Sap green and mineral green, taken from the watercolour pencil range, produce a versatile light green mix when mixed with sepia.

A – light green mix.

B – Two layers of the light green mix.

C – Three layers of the light green mix.

Tip

Use plenty of water to make your watercolour pencil washes translucent for wet on dry overlays, and to achieve full effect from the inktense pencil glaze.

Buttercups

Yellow flowers start as simple flat shapes.

Directionally placed strokes establish seemingly random negative shapes.

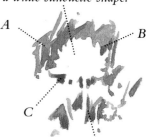

Use sun yellow inktense pencils to glaze if you wish to create more vibrant buttercup hues.

White clover

Take pencil strokes across the petal edge and 'in'.

Place darks on either side of a retained light strip.

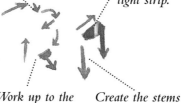

Work up to the edge of the flower petal crisply and pull colour away.

Create the stems using downward pencil strokes.

This clover head is seen as a white silhouette shape.

Use varied negative shapes to create the impression of the flower head.

Shadow and grass mixes

Copper beech, burnt carmine and indigo combine to make a neutral brown mix.

Bottle green and raw umber make a muted green.

Mix this muted green with indigo or burnt carmine for the shadow recess shapes.

Grasses

Establish the basic shape with a series of short, zigzag, pull-down strokes.

Add extra tonal overlays once the basic shape is in place.

Use long sweeping strokes for the blades of grass.

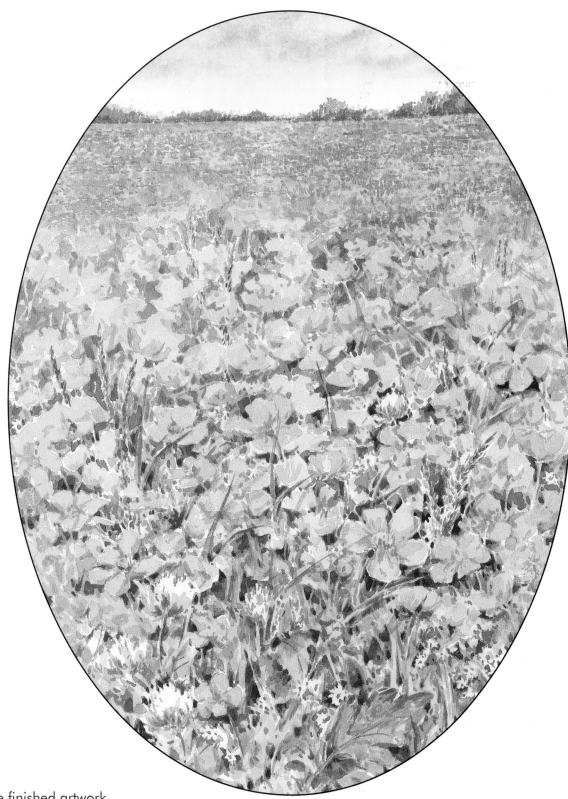

The finished artwork

The introduction of white clover in the lower left foreground and a little further up into the picture encourages your eye to travel into the composition. With the clover and buttercup petals giving so many circular shapes, the introduction of tall grasses provides important contrasting shapes and, where seeded, hue.

Diluted indigo was used for the sky, with white fluffy clouds, and also as a gentle diluted overlay to soften the images of the distant trees.

Index